MAGRITTE

Magritte

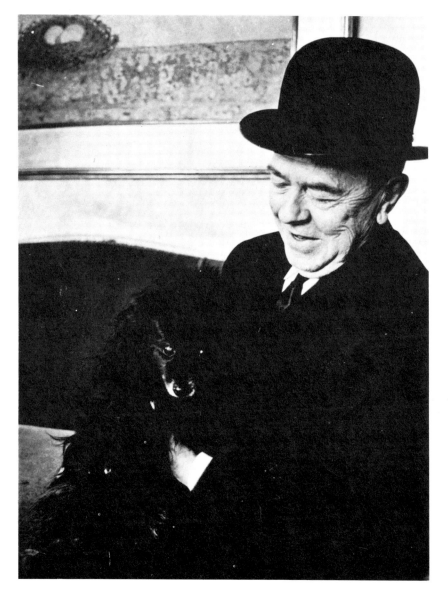

BY Bernard Noël

BONFINI PRESS - NAEFELS

Title page: PHOTOGRAPH OF RENÉ MAGRITTE
WITH HIS DOG

Translated from the French by:
JEFFREY ARSHAM

Collection published under the direction of:
MADELEINE LEDIVELEC - GLOECKNER

Library of Congress Cataloging in Publication Data

Noël, Bernard, 1930 -
 Magritte.

 Bibliography: pp. 94-95
 1. Magritte, René, 1898-1967.
ND673.M35N613 759.9493 76-57235
ISBN 0-517-53009-0

PRINTED IN ITALY - © 1977 BY BONFINI PRESS, INC. NAEFELS, SWITZERLAND
RIGHTS OF THE ILLUSTRATIONS BY MRS. GEORGETTE MAGRITTE

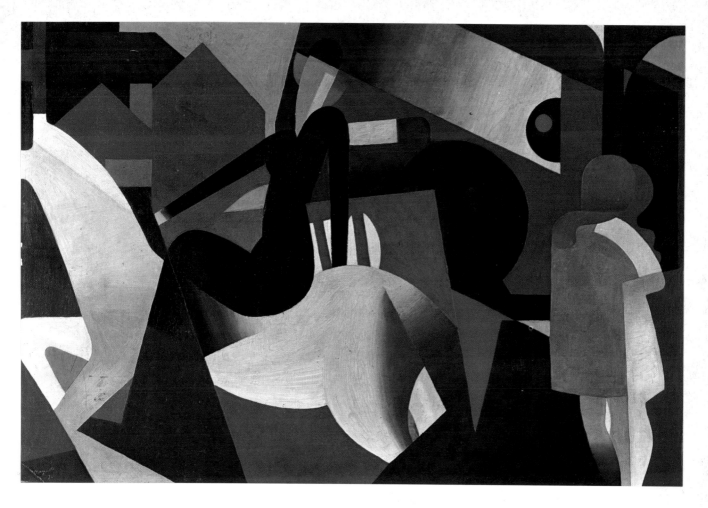

THE RIDER, 1922
Oil on canvas, 23$^1/_2$" x 35$^1/_4$". Private Collection, Brussels

What is the meaning of an image? We have been led to believe that it coincides with its explanation, that is to say, its emptying out. Yet it so happens that while I reel off the line that would explain, the image remains stationary, fixed, and that at the very instant when I suppose myself done with it, if I view it one more time, I am compelled to realize that I have taken atmosphere for visage. When everything is said of what is there, it is indeed that *everything,* which is not to be found in what is said. In fact, the sheer clarity of the image poses a problem, for the more I assure myself I see it, the less I hear it.

And then, is it possible to explain, without taking into account what enunciates the explanation, the mouth; sees and hears it, the ear; what writes it out, the hand? And if every image is traced by the hand, how does the eye that sees it retransmit it to the hand that writes of it? The visible and the audible meet in the hand, and the visage, which sees and speaks and reads, is less ambiguous than that hand which, in the last analysis, is able to take charge of everything, when it seemed to have just the function of holding the tool. The body puts forward its head, yet holds its identity in its hand.

It would be fascinating to learn that what we have termed objectivity and subjectivity are linked to this double circuit, whose activity always winds up coming back to none other than ourselves. And is it not astonishing that our most intimate operation, the least noisy, that of thinking, is effectuated only with the help of the audible which, notwithstanding, has the properties of something exterior? By its nature, the body emits nothing but rumors: it borrows those sounds which render the mouth an instrument of speech. Much of the audible cannot be put into words, while everything visible is potentially image, but it is not for that reason that the tracing hand is spared the desperation of the writing hand: the origin of images is evident, that of words is lacking, and its absence is apparent... And the evident being immediate, the image in its immediate expression disposes of the power of the original: it makes see.

The image is, no doubt, on the same terms with reality as the view. We know the visible only as seen, but what distinguishes it? Resemblance satisfies us. After all, (its) use defines object, and we would not insist on more, from that object's image. Representation is a game, which proceeds even if we forget that in this game all our dealings with the world are at stake.

Here is an image. It is as simple as it can be. It consists of three elements: a uniformly salmon colored background and in it two objects: a glass of water and an umbrella. The glass is three-quarters full, and maybe we should consider, as a fourth element, the water it contains. The association of these two objects is bizarre, yet would be no more so than many others, were it not for the umbrella, which is open, with its fabric fully stretched out, surmounted by the aforementioned glass. The stick of the umbrella is apparently wooden, and near its tip is the catch, which juts out just above the top of the handle, which appears to be made of bent bamboo, for it has six prominent nodosities. The glass is to be found in the would-be place of the tip of the stick, which is planted on the ground and perhaps leaned on, when the umbrella is manipulated like a cane. The visible part of the umbrella's fabric features the usual six ribs, which form the curved outlines of the five sections of the half-dome. Close to the bottom, at the left of the image, a quite legible signature: Magritte.

This detailing of the painting is less striking than a first look at the image, for the disposition of its elements is immediately evident. And even if I managed to summarize everything in a single phrase, it is probable that this phrase would turn inside out, as pitifully as an umbrella all but wrung out by the evident. And yet, one will retort, the image here is so simplified that it would appear difficult *not* to say it as it is... It is true, or rather, this would be true were the image to align a glass and an umbrella in such a manner as to make us recompose that relation, in our perception, which the sight or memory of one or the other object induces. But then, this image is a painting — more precisely, it is a Magritte painting — and thus, it is unlikely that the latter so associates two such things by chance, as a joke, or with reference to their usual meaning. And that the last is brought into question, no doubt not without irony, so as to have it undefined. Thus, the clarity of their representation puts these two everyday objects out of service, to the extent that all of a sudden they elude us, in the very swoop of that look with which we approach them, recognizingly: their

The Use of Speech, 1927. Drawing, 17⁵/₈" x 15¹³/₁₆".
Collection: Isy Brachot Gallery, Brussels

« defection » is all the more strongly felt for the reason that we see nothing — nothing but a glass and an umbrella that are so aligned as to be deprived of their respective identities, as such.

One could speak of a case of traitorous resemblance. Here, immediacy would have it both ways: if a sensation of identification is not absent, the spectator is faced with a sort of dissembling, and is frustrated in what he recognizes at the very moment when he thinks he recognizes it. And this frustration — one could almost speak of a shock of non-recognition — is serious, for it menaces the order of things. Henceforth, our points of reference are mined, and the painting too, for the latter is no longer that homogeneous space where even distorted and deformed things demonstrate the continuity of their identities. The already-seen gives way to the visible, and it is the never-seen.

And reality will not come to the rescue of realism: the former has, so to speak, sanctioned the existence of the latter, that is sufficient; why does the latter have to take itself for the former? But then, what is there to say of an image presenting absolutely nothing to see but what is represented? If this painting, among all those of Magritte, entices me the most, it is because nothing can be « seen into it », but a glass and an umbrella, even though the arrangement of the representation forbids us to see nothing there except a glass and an um-

brella. And this contradiction is confirmed in its composition, through which the two objects come in touch the better to contradict one another, for one after all is supposed — that is its function — to keep water away, while the other is supposed to collect it. It suffices — there will be more illustrations later — to examine several paintings of Magritte, and one realizes that they all operate on contradiction, which thus is not but a peculiar impression. The advantage of this image, and the reason that I prefer it, is its exceptional nudity: no literary-poetical connotation can be imposed upon or read into it.

Here, it is time that I in turn contradict myself, for while limiting myself to this image, which I continue to look at, it is certain that I have not forgotten — even for an instant — that it has a title, with which I have always associated the painting. And this title is indeed literary: *Hegel's Vacation* (1958) (see p. 66). I am also aware that with Magritte the title is inseparable from the image, that they comprise a whole from which the title is not to be isolated, so as to explain. Continuing to view the glass and the umbrella painted on a salmon-colored background, I am obliged to recall the words « *Hegel's Vacation* ». Consequently, at the risk of a certain stiffness, I have undertaken the census of Magritte (painting) titles having a « philosophic » reference point. I have found: *Heraclitus' Bridge* (1934), *The Philosophical Lamp* (1937), *In Praise of Dialectic* (1937), *The Principle of Incertitude* (1944), *Treatise of the Sensations* (1944), and, stretching the point a bit: *Natural Knowledge* (1938), *The Empire of Reflection* (1939), *Intelligence* (1946), *Knowledge* (1961) (see p. 71) and *The Idea* (1966). Needless to say this survey has proven utterly insignificant; it reveals nothing, if not that the frequency of the « philosophical », among a thousand Magritte titles I have uncovered, is altogether minimal. The study of the glass and umbrella in Magritte's work has not been much more fruitful, and it has rather tended to make me regret not having chosen the pipe like everybody else: no umbrella other than Hegel's, and as for the twenty-one glasses inventoried (between 1929 and 1959), they have no characteristic but that some have a stem while others are stemless, there are fourteen of the latter. All the stemless ones are identical; the stemmed glasses have pretty much the same stem, with an oval bulge. Detectives and scholars have thus an awfully tough task, yet at times they must be obliged to think: so it is that I spent a day before the 1929 stemmed glass that Magritte named « the bird », and what a shock it was to discover the celebrated 1930 painting entitled *Dreamings' Key,* (see p. 33) in which an identical stemless glass is baptized « the storm ». How can one not ask oneself at this point, if the glass in *Hegel's Vacation* did not represent at the summit of its umbrella, a tempest in a glass of water?

So we find, with Magritte, glasses that are not glasses, but does it not suffice to change the name of something — no matter what — so as to modify its use? Patrick Debonne writes me: Sure things are but a means of keeping one's feet inside one's shoes; one avoids thinking too deeply. The glasses that we see in *The Alphabet of Revelations* (1935), *Spontaneous Generation* (1937) and *The Liberator* (1947) are identically stemmed and identically hieroglyphic. What meaning have they, in combination with the key, the pipe, and the leaf in the first two cases; with the key, the pipe, and the bird, in the third? Are the leaf and the bird interchangeable? Or must we agree with Michaux that « never is the owl more

8

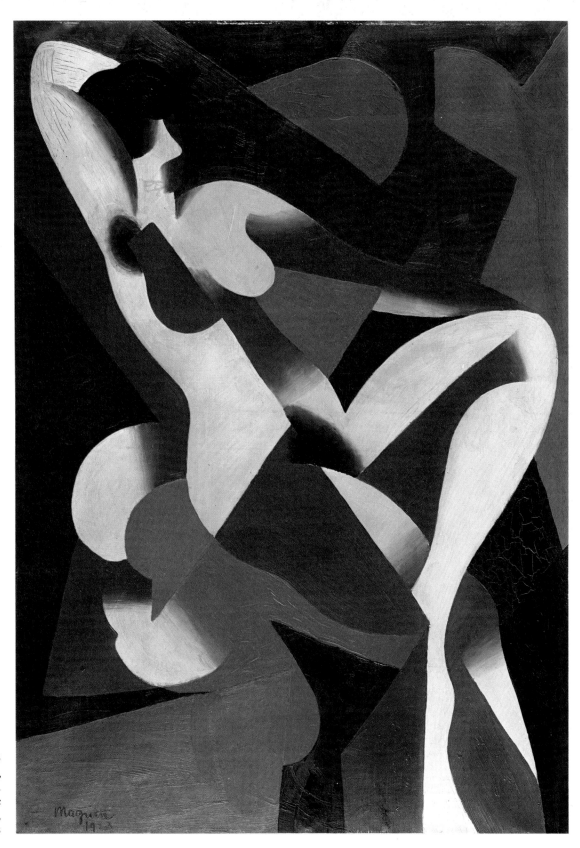

WOMAN, 1923
Oil on canvas,
$39^3/_8$" x $27^3/_{16}$".
Private
Collection,
Brussels

9

« CAMPAGNE III », 1927
Oil on canvas, 29" x 21¼". Collection: Isy Brachot Gallery, Brussels

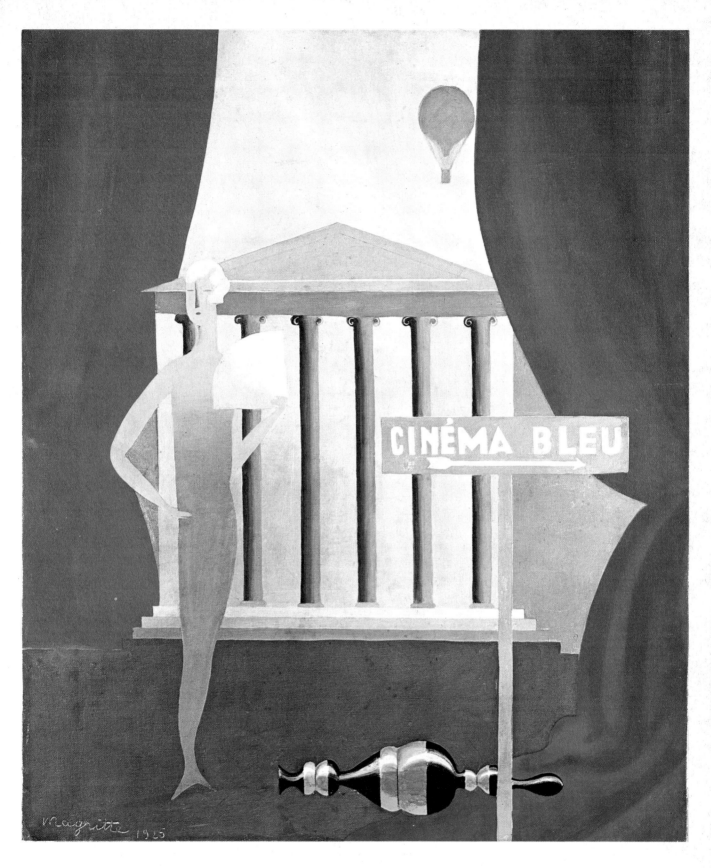

THE BLUE CINEMA, 1925
Oil on canvas, 25⁵/₈" x 21¹/₄". Collection: Davlyn Galleries, New York ©

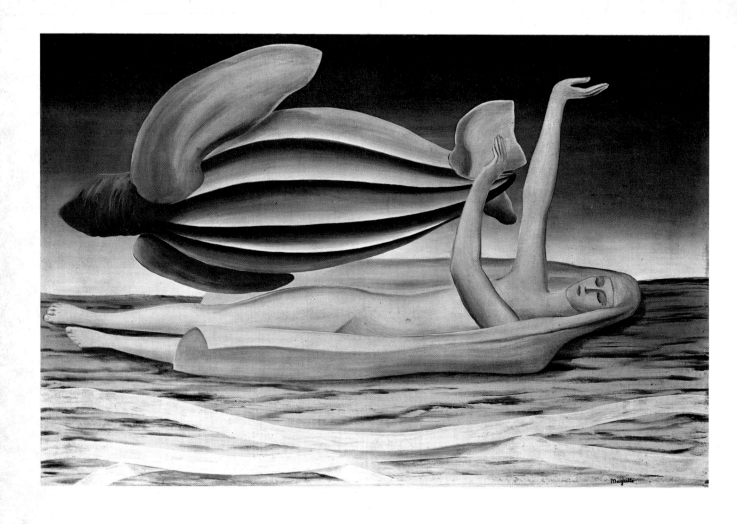

THE DRESS OF ADVENTURE, 1926
Oil on canvas, 31⁵/₈" x 47".
Private Collection, Brussels

12

THE LOST JOCKEY, 1926
Gouache and collage, 15^1/$_2$" x 21^1/$_2$".
Private Collection, New York ©

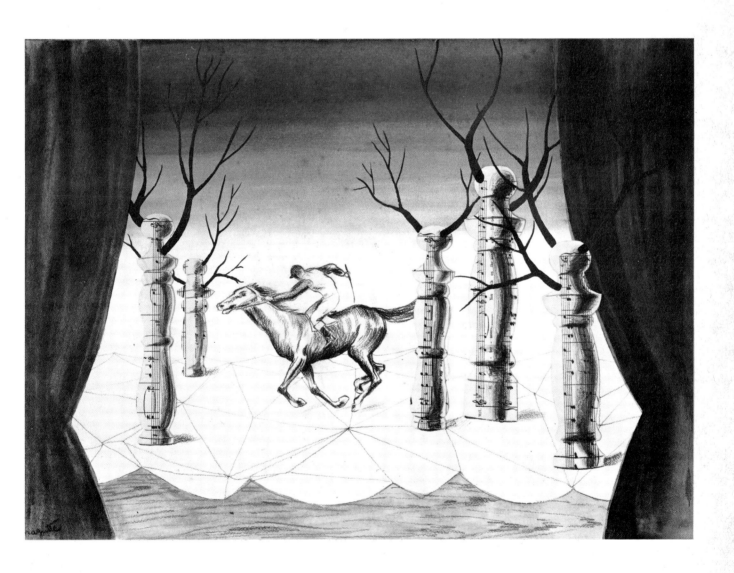

owl than when it is leaf »? We seek out meaning that will have us reassured, yet is the visible not that much more visible when it perturbs us?

The glass in *Personal Values* (1952) is empty and transparent, but most often, with Magritte, the glass is full of water. Only once in *The Rights of Man* (1947), have I found it held in hand... by a tumbler (« bilboquet »). Ordinarily, it is set upon a table, a windowsill, a railing, on the ground, whenever it is not floating on the back of *The Close Friend* (1958), where it is juxtaposed to a loaf of bread. This association, glass/bread is also to be found in *The Clearing* (1943), and in *The Wise Man's Carnival* (1947). An empty glass stands beside a bottle of wine in *The Portait* (1935) (see p. 26), but I have found only one glass full of wine, that of *The Sorcerer* (1952). Must one conclude that Magritte's glass has an affinity for water, and that it is as rare to see it filled with something else as set on an umbrella?

There is, so it is said, a secret sympathy of container with its content. This is probable, in that they adhere, so to speak; after all, try to drain an image of its meaning! But then, this is the opposite of the Danaïdes' torture: the image is fuller and fuller; one would be tempted to say that it grows out of itself. So, one day a friend added to my file the third issue of *Rhétorique,* a « little magazine » dedicated to Magritte. And there, between *Secret Agent* (1959) and *Sabbath* (1959), was to be found, in black and white, the reproduction of a painting that, with a uniform background, represented an open umbrella surmonted by a glass full of water. This time the umbrella's stick was metallic, its handles apparently leather; the glass had a stem. Underneath, the title read *Hegel's Vacation* (1959) (see p. 67). In 1959, as in 1958, the image was underlined by the same words, but the things represented, while bearing identical names, were not the same. And suddenly, resemblance entailed a detour, or a diversion that, in itself, rendered an identity tributary of its contrary and uncovered, in its figure, the senseless space of dissimilarity.

Here, posing side by side the reproduction of *Hegel's Vacation* (1958) and that of *Hegel's Vacation* (1959), it was as if I had seen how the sign covers thought working upon things, and also how the signifier becomes something worked upon... Resemblance contributes to this labor as the indispensable link joining, one to the other, two contrary states, so as to maintain them similarly readable in their difference: the Other must be like me, if I am to recognize, in him, the Other. If the world were not, from one to one another, decipherable by means of this model, would it be tolerable? But that will not do for us, we must keep on deciphering until that ultimate point where resemblance is absorbed, and at that point the Other springs forth, once again the unknown, that madness which we would hope to have eliminated by recognizing it, which now comes back, to threaten if not to haunt us...

When I view *Hegel's Vacation,* my view tends to become that image, and I, myself, tend to settle for this realism, which places the image in its reference to the objects it represents. And any explanation, rather than sparring with this realism, nourishes it, and that, contrary to what one may suppose, saps the meaning. Explanation drains the meaning, for it is not that movement (in the painting) which it adapts, but rather, as Magritte wrote to Suzi Gablik:

14

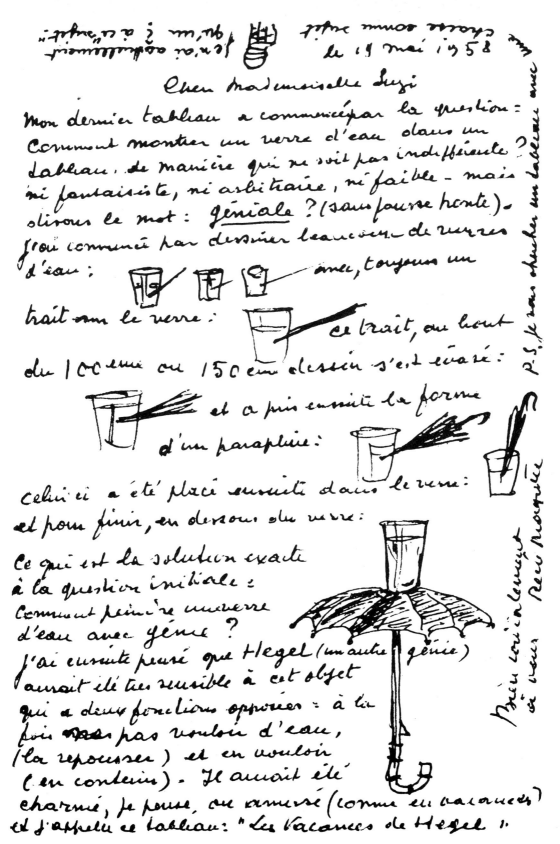

le 19 mai 1958

Cher Mademoiselle Suzi

Mon dernier tableau a commencé par la question: Comment montrer un verre d'eau dans un tableau, de manière qu'il ne soit pas indifférent, ni fantaisiste, ni arbitraire, ni faible - mais disons le mot: géniale? (sans fausse honte). J'ai commencé par dessiner beaucoup de verres d'eau: avec, toujours un trait sur le verre: ce trait, au bout du 100ème ou 150ème dessin s'est évasé: et a pris ensuite la forme d'un parapluie: celui-ci a été placé ensuite dans le verre: et pour finir, en dessous du verre:

Ce qui est la solution exacte à la question initiale: Comment peindre un verre d'eau avec génie? J'ai ensuite pensé que Hegel (un autre génie) aurait été très sensible à cet objet qui a deux fonctions opposées: à la fois ne pas vouloir d'eau, (la repousser) et en vouloir (en contenir). Il aurait été charmé, je pense, ou amusé (comme en vacances) et j'appelle ce tableau: "Les Vacances de Hegel".

P.S. Je vous enverrai un tableau avec

Bien cordialement à vous René Magritte

Letter from René Magritte to Suzi Gablik dated 19 May 1958

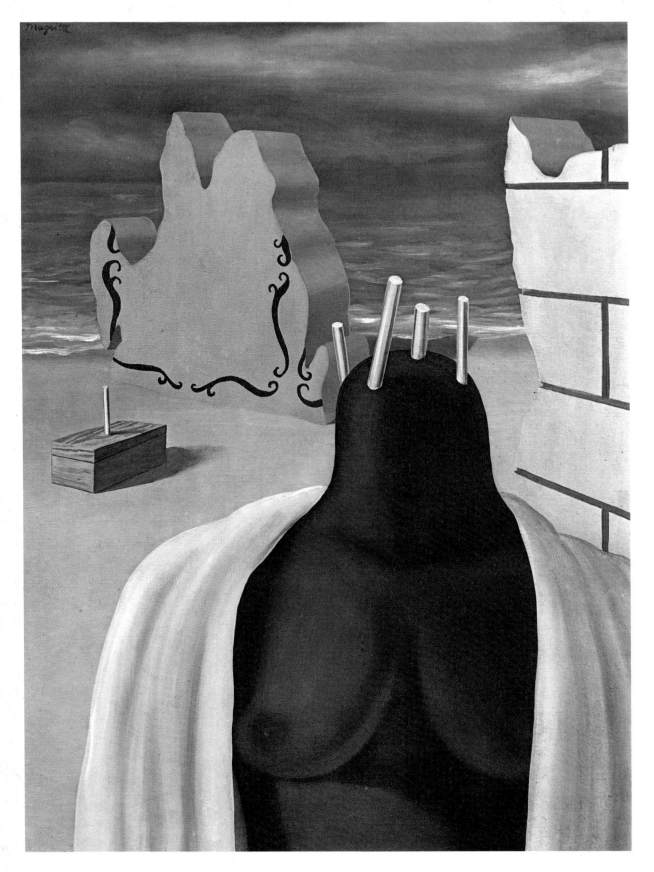

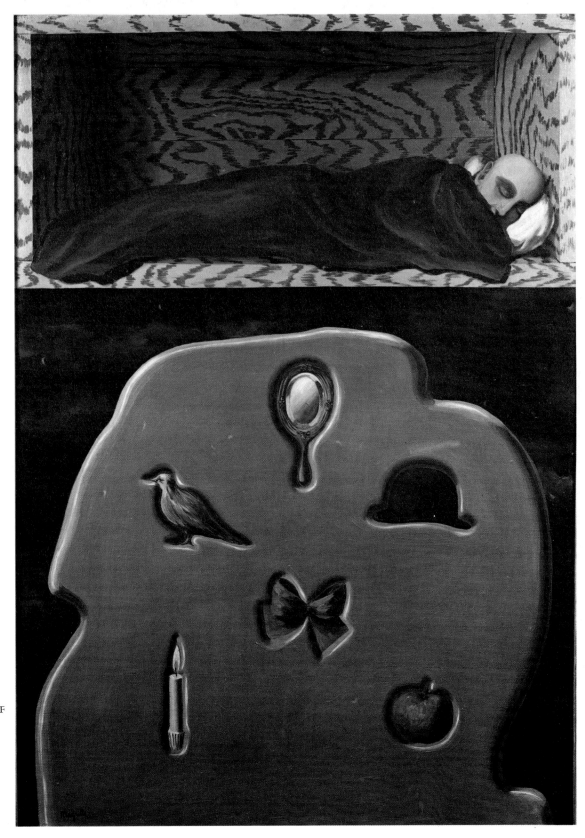

THE RECKLESS
SLEEPER,
1927
Oil on canvas,
45¼" x 31¼".
Collection:
Tate Gallery
London

THE ORDEAL OF
THE VESTAL
VIRGIN, 1926
Oil on canvas,
7½" x 28¾".
Collection:
Isy Brachot
Gallery,
Brussels

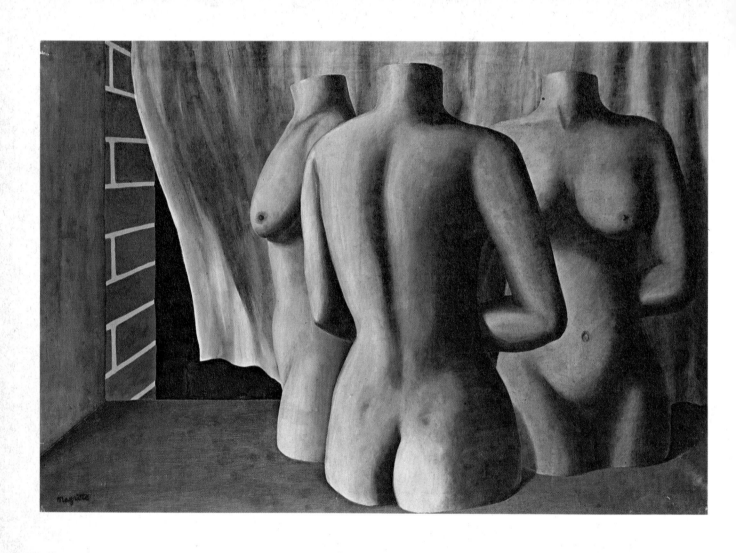

« Dialogue Dénoué par le Vent », 1928
Oil on canvas, 31⁷/₈" x 45⁵/₈".
Collection: Davlyn Galleries, New York ©

18

INTERMISSION, 1927-28
Oil on canvas, 45" x 64".
Collection: Mrs. Jean Krebs, Brussels

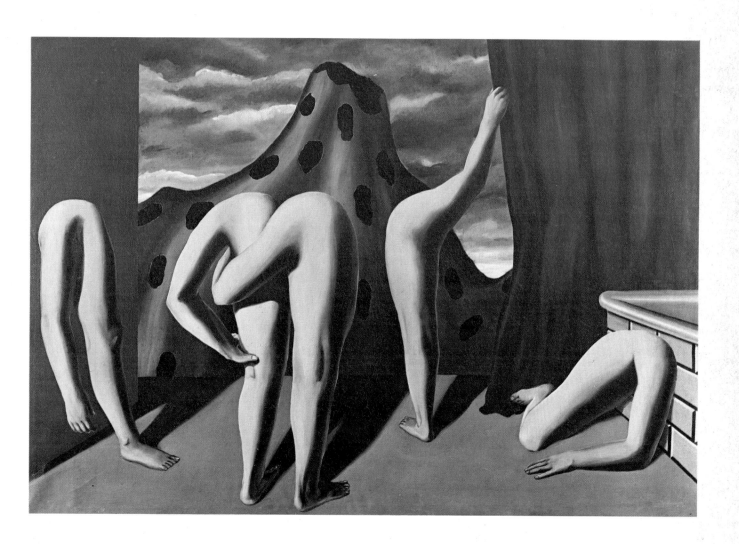

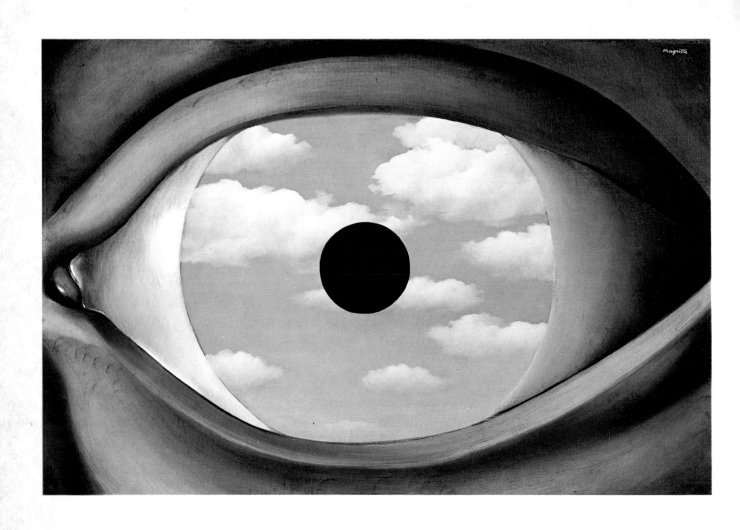

The False Mirror, 1928
Oil on canvas, 21¹/₄ x 31⁷/₈".
Collection: The Museum of Modern Art, New York ©

« La Présence d'Esprit », 1960 India ink 5⁵/₈" x 4³/₈".
Private Collection, New York ©

Lettre from René Magritte to Suzi Gablik, dated May 19, 1958.

Dear Mademoiselle Suzi:

My last painting was begun by the question, how can I show a glass of water in a painting in a manner that is not indifferent? Neither whimsical, nor arbitrary, nor weak, but, let us say the word: *genial?* (without false shame). I set out by designing many glasses of water: (3 glasses, sketched) with, always, a stroke in the glass. This stroke, after the 100th or the 150th sketch, became cupped, and then took the form of an umbrella.

Then the umbrella was placed in the glass, and to finish, underneath the glass.

This is the exact solution to the initial question, how can I paint a glass of water with genius?

I then thought that Hegel (another genius) would have been quite sensible to this object which has two opposed functions; not to want water (to repulse it) and to want (contain) water. He would have been charmed, I think, or amused (as if on vacation), and I call the painting: « Hegel's Vacation ».

Very cordially yours,
René Magritte

P.S. I am going to look for a painting with a chair for subject: (sketch of a chair) At present I've but a ? for this « subject ».

Suzi Gablik published the facsimile of this letter in her *Magritte* — in English — which came out in 1970: now, it is out of print. When one reads this letter, impossible not to be persuaded that in it, all is said. But what is said? That *Hegel's Vacation* is « the exact solution to the initial question: how to paint a glass of water with genius ». So that the point — and the meaning — of this image is to show a glass of water genially painted. This point does not affect the « container » — the glass remains a glass — but it affects the content: the glass does not contain water — or not just water — but (also) genius, and quite precisely, the genius of Magritte. Why not? First, nobody knows, better than Magritte, what he (meant to) put there; then, genius lacking any known reference point, why not promote this image from image to reference point, so that to the question: What is genius? anyone can henceforth reply: It is a glass on an umbrella.

Here are, now inseparable, *Hegel's Vacation* and the letter to Suzi. « I set out, writes Magritte, by designing many glasses of water... » This « many » — which, it is indicated, alludes to 100 or 150 sketches — does not simply denote a quantity, the examples furnished as illustrations demonstrate a progression, which indicates the operation of an experimental method. Magritte set out by asking a question, to which he sought an answer, by sketching. This sketched reflection, which is the basis of Magritte's work, was outlined — as a method — in 1952, in *The Map According to Nature:* « ...an object, any subject taken as question, it was a matter of finding, as answer, another object, secretly bound to the first by links sufficiently complex as to give verification of the answer. If the answer became evident, the meeting of the two objects was striking ». The letter to Suzi Gablik concurs with the

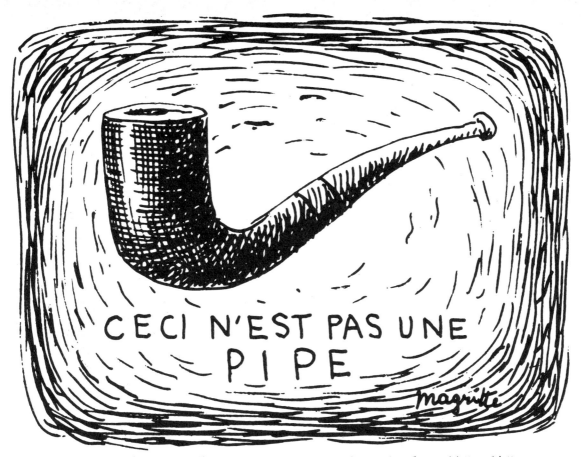

« L'Air et la Chanson » *(This Is Not a Pipe), 1962 Original etching 4$^1/_2$" x 5$^3/_4$".*
Private Collection, Courtesy of Timothy Baum, New York ©

text and shows that, with Magritte, thought labors visibly. Once the solution is found, thought dances around the object-answer, and it is in this ludique movement that it finds its title: *Hegel's Vacation*. There is no tenable explanation for this: there is just flight of words escorting image.

Now, the view that I bring to bear upon *Hegel's Vacation* must « destruct », within itself, its reference points, so as not to be opposed to the awareness I now have of the nature of the object-answer. My view must take a leap forward, similar to that which each word has us accomplish in distancing us from what it names, but it must this time do it against words. What I have before me is no longer, in fact, a glass on an umbrella, but an object which, though composed of a glass and of an umbrella, does not now maintain any relation, in its function, to the purpose these two have, as useful objects. This object will never be named, for my view comes close to it only in un-naming it, that is to say, in wrenching it out of all « realistic » identification. Then, and as a product of this wrenching, comes the view that the object addresses to me. But how can one put this? On the verge of « materialist » experience, language wavers — or me. What happens if it is no longer I who think, but the object which makes me think? From the moment when the object of

23

Hegel's Vacation becomes sufficiently equivocal to function, no longer in relation to things that compose it but in relation to their contradiction, which it resolves, it is — has become — a mental object, which materializes nothing other than the thought of Magritte. This thought, the mental object is and is not. It is to the extent that it designates thought's result; it is not to the extent that it is stationary, but this contradiction also bears on its functioning. There was an instant, in which the painter's thought — the whole of his thought — entered the object that the painter depicted; the trouble is that this object was *already* inside the thought. That is how, to sum it up, thought resembles the visible, but also how it invents the visible, by making it spring out of that obscurity, inside us, of matter invisibly laboring toward daylight.

The difficulty of describing this labor derives from its doubleness, the same doubleness as in the word «reflected», which may mean either reflected upon (thought out) or (light) reflected. Magritte has in fact depicted this dialectic in a celebrated painting, *The False Mirror* (1928) (see p. 20), where one sees an eye reflecting the clouded sky. This eye contains the view — the seen — instead of the viewing; it is an eye thinking the image, reflecting upon it. I think inside myself, but I also think outside myself in a perpetual inversion of the outside and the inside, of the projected and the reflected, whose crossing produces this mental object: the image. And mental the object — as such — is to be seen, with *its* view — that is to say, that having relieved it of what it is not (a glass on an umbrella), I have no choice but to go forward toward that object which must have sprung up, before the mental view of Magritte. So, with this view — and on account of it — my thought exerts itself trying to retrace that thought, which was once Magritte's. An endless task, needless to say, for this (mental) object is neither something to be substantiated, nor the key to a truth that it will enable me to approach. No, it is nothing but itself — nothing but the trace of a functioning, which I try to reproduce, which makes me think.

This reciprocal movement is not linear. It entails a return, which is a takeoff, just as reading is a return, taking off from which, thought goes beyond the already-thought. Meaning is there, in this coming-and-going that apprises itself of its trajectory so as to demand of it — the trajectory — the means to take it still further. There is no truth-country in which one could install oneself proclaiming, here is what this means. The mental object is enlightened, so to speak, by a questioning that nothing can exhaust — no answer. And that is how it rejoins that interior experience whose characteristic is to admit no authority over itself, other than itself. The mental object is a challenge, for it obliges us to think, beyond art, toward something utterly devoid of any trace of purpose — nothing artistic, just the pulsation of an inexhaustible interrogation. At a certain moment, thought looks back, and instead of being reassured of and by everything that it has « enlightened », it sees that this very light — its daylight — is riddled with darkness. We will never be possessors, nor be appeased. Concluding his seminar on Heraclitus, Heidegger says: « With Hegel there is a need for the appeasement of the thought. For us, on the other hand, reigns the distress of non-thought in the thought ».

Magritte read the philosophers, at least those who have been mentioned or cited

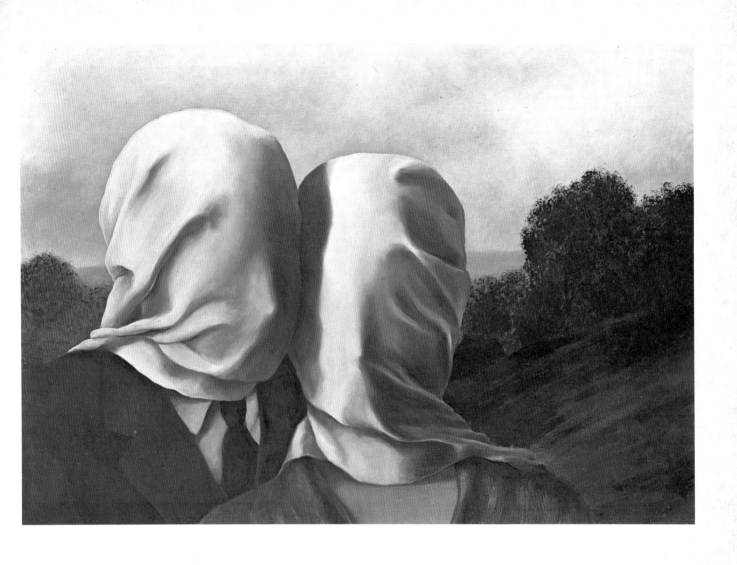

THE LOVERS, 1928
Oil on canvas, 21¼" x 28¾".
Private Collection, Brussels.

PORTRAIT, 1935
Oil on canvas,
28³/₄" x 19⁷/₈".
Collection:
Museum of
Modern Art,
New York.
Gift of Kay Sage
Tanguy ©

26

THE RED MODEL, 1935
Oil on canvas, 21$^{15}/_{16}$" x 18$^3/_4$". Collection: Musée national d'Art moderne, Paris

BLACK MAGIC, 1935
Oil on canvas, 31⁵/₈" x 23¹/₂". Collection: Mrs. Georgette Magritte, Brussels ©

above, but his mental object has this advantage over philosophy: it will not stop bringing us back to the umbrella — which is sufficiently ambiguous as to be at once serious, and mystifying. Which is what *Hegel's Vacation* « proves »: I can laugh at the proposition I just put forward, but also laugh at this laugh and keep on advancing... After all, this glass on the umbrella, why would it not be genius? It is in any case the genius of contradiction, genius speaking of everything it does not say, and silencing itself so as to make us hear that which, precisely, it silences to the point of seeming to be its mockery.

In Magritte's painting, thought — rather than view — is at stake — a thought that we have the habit of fastening to the said, to the heard, and that, here, has the violent strangeness to present itself to be seen, and to be silent. Nothing is more secret than the visible, one might say that there is no better mask than evidence. As for silence, who listens to it? And yet, that silence is clearly signified, with Magritte, by all those characters who turn their backs on us, who are headless, or who hide their heads: from *The Lovers* (1928) (see p. 25) to *The Idea* (1966), there are dozens of examples. And what is to be said of the metamorphosis, into a visage, of that which, inside us, is speechless? There are few images as aggressive of that of the trunk become head, of which Magritte has sketched a large number of versions, with but a single title: *Rape.* Agressive, but is it not especially so, because this image is a figure of the unthinkable, that is to say a silent cry? And then, there is a real silence in this world where all is mineralized: the furniture, things, and people themselves (*The Song of the Violet,* 1951, and the series: *Memory of a Voyage,* 1951-55) (see pp. 59, 68) or in the architectured piling of the rock quarters in *The Art of Conversation* (1950).

Those who turn their backs on us are alone. They face the same thing as we: the surface of illusion, of the image, but they have not the possibility of turning away from it. And dealing, without illusion, with illusion, demands silence, and silence renders solitary.

And if meaning were tributary of illusion? Would it not then be a question of saying the meaningless? There is, with Magritte, between silence and solitude, expectation: To what are we to attribute them? Or rather, of what, can we make them the attributes? These are not matters ordinarily taken up by painting. Maybe they spring from Magritte's necessity of isolating each object in such a way that it is perfectly itself, and perfectly turned away from itself. This is all the more striking when we consider that Magritte is not a « sentimental » painter à la Van Gogh, who crams the surface with expressions of self — no, Magritte paints objectively, dispassionately, and he does not utilize the object so as to make a painting of it but rather to restore it, one would say, to a world in which things have their own eyes. In this world, which is neither utilitarian, nor humanistic, things refer to their function no more than they do to the painter: they've dropped their gloves and express nothing which can be limited to their reference point. The solitude, the silence, the expectation are thus, in this world, not a sought-out expression, but instead, the consequence of a separation. We suffer them, but maybe they are just in us — and roused by an image which only notes our absence.

Memory brings back insistently a phrase: « Expectation is not described *externally,* by the indication of what is expected; the description of expectation by that of

Clouds, undated
Gouache, 13¹/₂" x 13".
Private Collection

▷

The Therapeutist, undated
Gouache, 19" x 13⁵/₈".
Collection: Harry Torczyner, New York ©

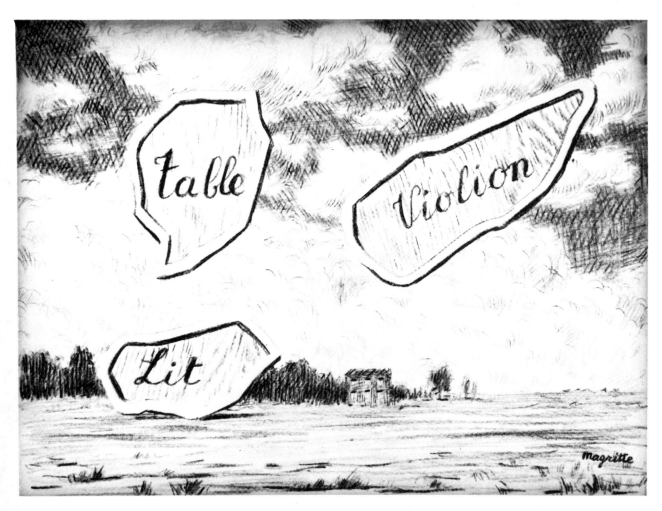

Landscape with Table, Bed, Violin, 1965 Pencil drawing 8³/₄" x 11⁷/₈".
Private Collection, Courtesy of Timothy Baum, New York ©

which it is the expectation is an internal description ». (Wittgenstein, *Philosophical Notes*, III, 29). Could it be that absence, expectation, solitude, and silence are the external coordinates of a certain spark destined to trigger the mental dynamic *internal* to the image of Magritte, which would be particularly his? It is a matter of passing on from the representative aspect of the object to that which it formalizes and from there, by a sort of flexion, to a movement that has nothing to do with representation but is production. These passages are the labor.

The words « external », « internal », and « passage » suggest an underlying, but what underlies the image is nothing other than the spectator whom that image, precisely, puts to work. The image's materiality finds the density necessary to *its* working with (in) the spectator. Most images make but a single impression; the visible, with them, hides nothing but a piece of wall. With Magritte, for whom the invisible is just the visible hidden by the visible, the image hides what it calls for: a reading — a reading at once serious and

DREAMINGS' KEY, 1930
Oil on canvas, 31⁷/₈" x 23¹/₂". Private Collection

playful, which is mobilized by a series of contradictions, the most fundamental of which is summed up in the statement often repeated by Magritte: « Painting must serve something other than painting ».

And so, what must it serve? To think. To depict thought. The art of painting, specifies Magritte, « allows the description, by the painting, of a thought liable to become apparent. This thought is comprised exclusively of the shapes that the apparent world offers us: persons, stars, furniture, weapons, solids, inscriptions, etc. »; he adds that these shapes need not be represented with originality or fantasy, which would be detrimental to resemblance, but with precision. And, he continues, « if it happens that one is moved or interested upon viewing an image of resemblance, it is not to be deduced that it "expresses" an emotion or that it enunciates an idea. This would be as naïve as the supposition, for example, that a cake "expresses" what the baker thought while realizing it » (cf. « Magritte par lui-même », in *L'Art Belge,* Magritte issue, January 1968).

The words governing these citations are: «thought», «figures», «apparent world», « resemblance », « express », « emotion », « idea », words whose connotations, for Magritte, become most evident, upon a perusal of his writings:

— Thought: « For me, says Magritte, thought is composed of visible things only, painting can render it visible ». And, « I think as if nobody prior to me had thought ». And « Writing is an invisible description of thought and painting its visible description ».

— Figures. The meaning is clear, it has to do with everything populating the visible: objects, plants, people, etc.

— Apparent world. It is in sum, and quite evidently the whole of the visible, and there is no « other » world, for as I have already said, the invisible is but the visible hidden.

— Resemblance. This is Magritte's key word, as he explains: « Resemblance is tantamount to the essential act of thought: that of resembling. Thought resembles by becoming what the world endows it with and by restoring what it is endowed with, to the mystery without which there is no possibility of world, no possibility of thought. Inspiration is the event through which resemblance springs forth. Thought resembles, only when it is inspired », (catalogue for the Liège exposition, Nov.-Dec. 1960). And, « Resemblance is not interested in seconding or challenging common sense. Spontaneously it reunites the shapes of the apparent world, in an order offered by inspiration... » (op. cit., *L'Art Belge*).

— Express. The phrase, in which this word appears, clearly indicates that the image does not « express »; it expresses nothing. The image, in no case, can serve as its own explanation, besides which, there is no explanation. « To try to interpret an image of resemblance — so as to exercise, upon it, who knows what liberty — is to misunderstand the inspired image, putting in its place a gratuitous interpretation that, in turn, can serve as the object of an endless series of superfluous interpretations » (op. cit., *L'Art Belge*).

— Emotion. It is not *in* the image, ever. « An emotion cannot be represented by a painting ».

— Idea. « An idea is not to be seen by the eyes. Ideas have no visual appearance, so it is that no image can represent an idea ».

The Alphabet of Revelations, 1948 Drawing. Private Collection

PICTORIAL
CONTENT, 1947
Oil on canvas,
$28^3/_4$" x $19^7/_8$".
Collection:
Isy Brachot
Gallery, Brussels

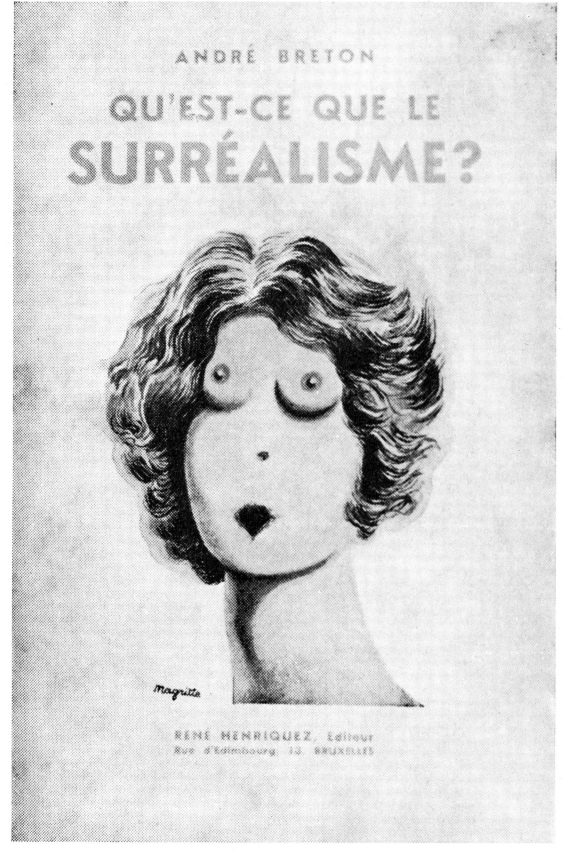

Sketch for the Invention of Fire, undated. Pencil on paper
Private Collection, New York ©

These diverse citations tend to feature two other key words to which I shall make reference: « mystery » and « inspiration », and they show that, in the last analysis, « resemblance » and « thought » are synonymous, for Magritte. But then, what is a thought that « resembles », instead of « thinks », and which apparently has no other function but « to restore that which is offered to mystery »? Paul Nougé, who was for many years Magritte's accomplice and who is — with Scutenaire — his best critic, wrote an important text pertaining to this problem, in which he said:

« Painters are painters, that is to say, their consideration of the object is limited to their thinking of how best to exploit it for the benefit of their painting. This stroke

*Study for the « Mental Universe », undated. Drawing
Collection: Mrs. Georgette Magritte, Brussels.*

will work, so they suppose, this scene, this tree, this color. / And that is all it takes implacably to limit their thought to the appearances, to deny it all profound effectiveness. This is not a pipe, retorts Magritte. / So it is that one must conceive of imagination in an altogether different manner. The object shall be considered not as the more or less competently treated subject of the painting but as a concrete reality, no longer for its sole visual appearance but in the midst of universal complexity. / And one will be obliged to observe that the consideration of — to think — an object cannot be reduced to the creation, in self, of its more or less passive representation. To consider — to think — an object is to interrogate it, in its essentiality and its specificity, to put it *into question* with all the precision of which the mind is capable. It is to await a reponse modifying the relation which that object maintains with the rest of the universe and with ourselves, response that illuminates it while, at the same time, enlightens us. / Understand the world in transforming it, such is no doubt, our authentic function. / To think an object, is to act upon it ». (*Forbidden Images,* reedited in *Histoire de ne pas rire,* pp. 257-258).

Paul Nougé continues: « Which objects must man judge the most important? Surely, the most common. The importance of an object is in direct ratio to its banality ».

Do the glass and umbrella in *Hegel's Vacation* owe their importance to their banality or to their unprecedented juxtaposition? They tell us something, immediately, as we recognize them for what they are; as for their juxtaposition, it challenges this recognition, yet the challenge has to do with us, and only us. It is solely in the idea we make of them, and the function that we lend to them, that glass and umbrella rule one another out. No, they are of quite another currency: one can couple them, and this arouses something in us, though it is but a shrugging of shoulders... I quote Paul Nougé: « Here again it is the real that is envisaged, not some aggregate of abstract qualities, but this dialectical system of a virtually infinite wealth that is formed, in the instant when we consider it, by a *thing* with *ourselves* — this dynamic whole in which intervene, in the form of exchanges, innumerable powers, be they sensorial, effective, or intellectual. » (op. cit., p. 259).

The hybridization glass-umbrella endows its product with an energy that a glass and an umbrella, considered separately, would not have. This energy focuses our attention and stimulates, between the « thing » and « ourselves », that «dialectical system» of which Paul Nougé writes — a system that is made to function, and not so as to answer a question such as: What is the meaning of this image? It is — this system — in itself the answer without answer. At bottom, an image has no other « meaning » than to open our eyes, and then there rests but one matter to think about: How — and to what extent? — does the retinal and the mental coincide in us...

It is time to be done with the idea that meaning would be explanatory. Explanation serves simply to domesticate our surroundings. And meaning will not be the accomplice of that generalized appropriation that transforms reality into nomenclature; it is, on the contrary, what prevents us from mastering things, for it has no end. Meaning is a relation producing meaning: it is vivacity, not fixing; it transforms and materializes. What does this transformation lead to? It is infinite, that is to say, interminable.

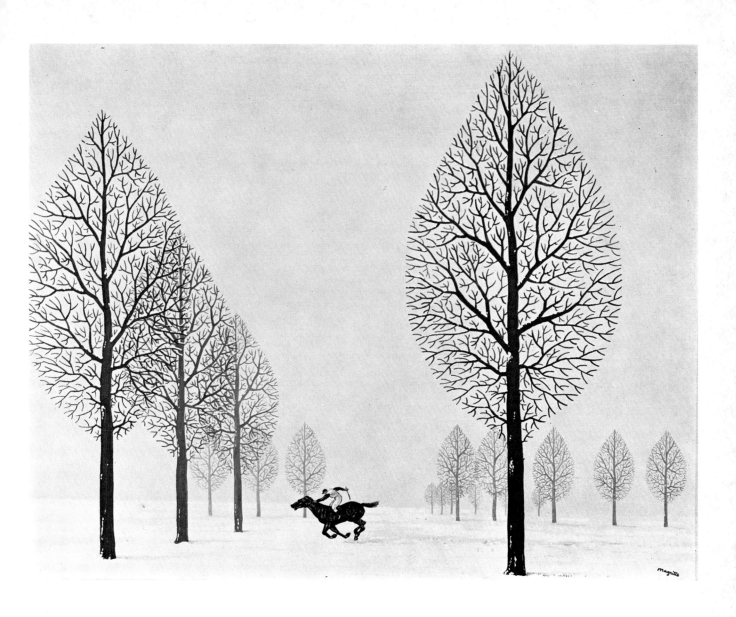

THE LOST JOCKEY, 1942
Oil on canvas, 20³/₄" x 25¹/₂".
Collection: Mr. and Mrs. Nesuhi Ertegun, New York ©

41

THE MENTAL UNIVERSE, 1947
Oil on canvas, 19⁷/₈" x 27¹/₄".
Private Collection, Brussels

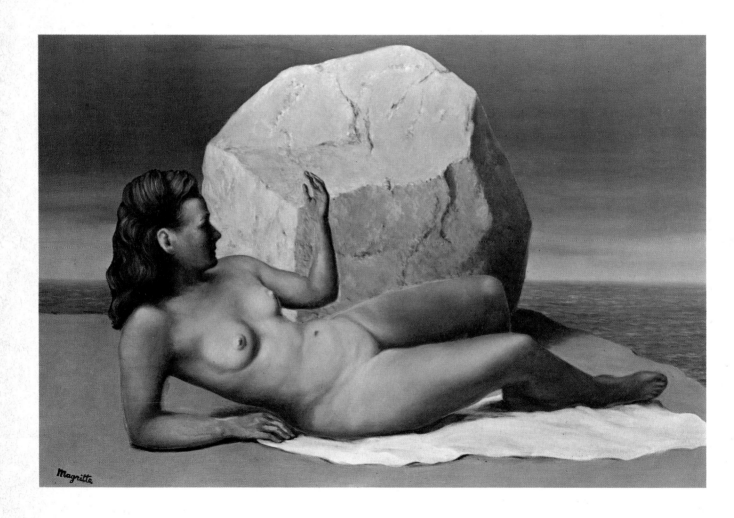

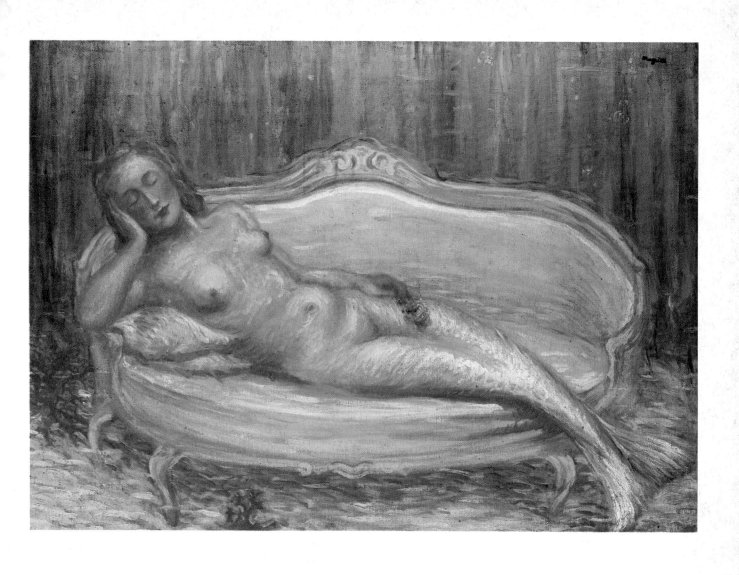

THE FORBIDDEN UNIVERSE, 1944
Oil on canvas, 31⁷/₈" x 25⁵/₈".
Private Collection

43

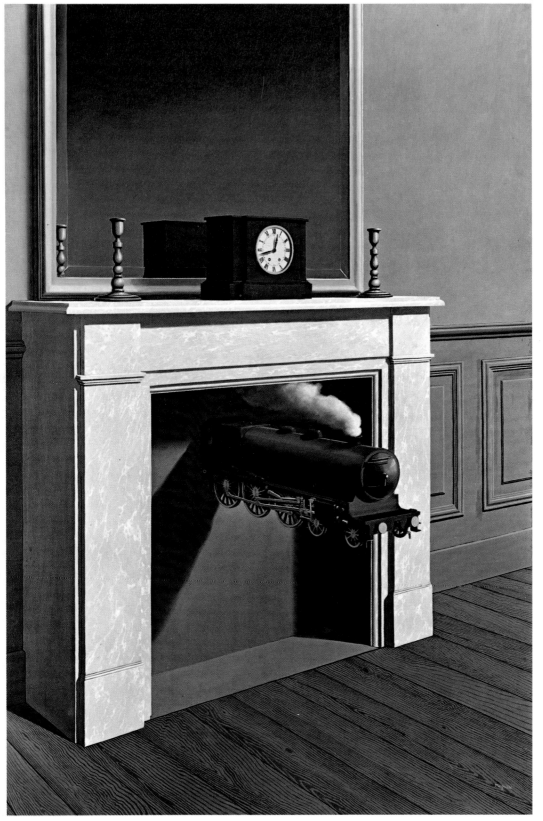

TIME TRANSFIXED,
1939
Oil on canvas,
57^1/$_2$" x 38^3/$_8$".
Collection:
The Art Institute of
Chicago,
The Joseph
Winterbotham Fund
Income ©

« LA LÉGENDE DES
SIÈCLES », 195
Gouache, 8^1/$_4$" x 6^1/$_4$'
Collection
Davlyn Gallerie
New York ©

44

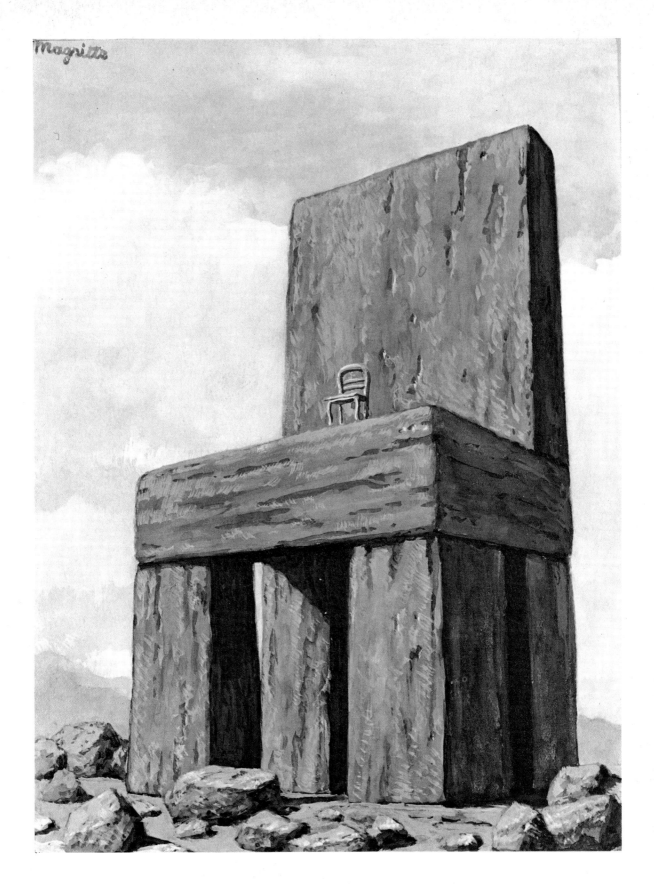

45

Illustration for the « Songs of Maldoror ». Drawing

Illustration for the « Songs of Maldoror », 1948.
Drawing 12" x 14". Private Collection, New York ©

UNTITLED, 1927
48 Collage and gouache, 20⁵/₈″ x 15³/₈″. Collection: Mrs. Jean Krebs, Brussels

Magritte writes: « Being capable of answering the question: What is the *meaning* of these images, would correspond to making Meaning, the Impossible, resemble a possible idea. Attempting to answer, one would recognize a "meaning". The spectator can see, with the utmost liberty, my images *such as they are,* while trying, like their author, to think Meaning, I mean to say the Impossible ». (cf. *Thought and Images*).

« Meaning » and the « Impossible » are to be compared to « mystery », such as it appears in the phrase, already cited: « Thought resembles by becoming what the world endows it with and by restoring what it is endowed with, to the mystery without which there is no possibility of world, no possibility of thought... » What is this *mystery,* which, I have already noted, is among Magritte's key words? Here it sounds rather like the ultimate end...

Magritte does not define the word in his writings, but he uses it often enough so that, by citing in context, one has some chance of approaching the meaning he ascribes to it. And first, so as to rid it of any religious or mystical connotation, here is an extract from a letter to Patrick Waldberg, cited by the latter in his opus on Magritte (pp. 238-241), and dated June 1, 1965:

— « Don't forget, I beg of you, what Poe says in *The Power of the Word,* when Oenos and Agathos converse. It has to do with the Almighty, who knows everything, but does not know himself, for he is the *one thing,* who must remain for HIM, unknown to HIMSELF, I don't exactly recall the text. But, of mystery — I don't say the Almighty — I think the same thing. It will not be someone or something "thinking", or a "substance" or a "being". Thus, it is an absolute challenge to our mind, which cannot admit that the lack of "being" is not "non-being" or nothingness. Hegelian dialectic goes beyond this contradiction with a higher system: Becoming satisfies the mind... under the condition that it be Hegelian. That satisfies my mind in this sense that the dialectical movement is intelligent and creative. But intelligence, beautiful as it may be, is incapable, for me, of bringing into doubt that mystery without which there would be no possibility of intelligence ».

— « The banality common to all things is the mystery ». (In *The Ignorant Elf,* 1955).

— « The feeling we have while viewing a painting is not to be distinguished from the painting, nor ourselves. The feeling, the painting, and ourselves are reunited in our mystery » (cited by S. Gablik).

— « The visible, in the world, is sufficiently rich to constitute a poetic language evoking mystery » (in *Rhétorique,* n. 12).

— « My defeatism corresponds to the disappointment of existence — and to the absolute prohibition of the belief that mystery (without which nothing would exist), can serve as refuge, be of any help » (letter to P. Waldberg, cited by him p. 241).

These last words epitomize mystery. It enchants and despairs, for it promises yet takes away that vision that would succor us. Mystery is as inexhaustible as our thirst for mystery. Each of Magritte's images is a point of view, which gives way to mystery; and mystery gives way only to itself, indefinitely. And so the way leads to the way, and not

to the goal; thought resembling makes us resembling — and what is a limit that compels us to think the unlimited?

There is a visible that calls for the excess of seeing — as for this visible, everything indicates that already it has been partially restored to mystery. And is this not — also — the secret of Magritte's images? They suggest our accepting something accomplished — of which they are the performers. When Magritte writes, he exposes what is to be done; when he paints, he does it. And before observing what has been « done », it is I who become the thinker, so as to restore the mystery. Above all, considering the mental object, I read — from its side — a view that I did not dare to describe. After all, try to speak of viewing a hybrid of glass and of umbrella, without bursting out laughing at your idealism! The mental object is the act of thought when it manages to « resemble », and it is also the realized persistence of this resemblance. Maybe it — the mental object — is the unreasonable reason why Magritte's paintings have a tendency to want to budge — but how can one put that? Ordinarily, a painting is there before its spectator; Magritte's paintings demand of the spectator that he be there before them.

The glass and umbrella of *Hegel's Vacation,* if they introduce mystery, do so, in any case, without seducing. It is too easy to pass off Magritte as a harbinger of the bizarre: we are mystified, but never — so to speak — mysticized. As René Passeron writes, « With Magritte, the "unrealizing" entails a metamorphosis, which is less a marvelous transfiguration than a cold triumph of irony » (in *René Magritte,* p. 58). One could quibble over the term « unrealizing », for if Magritte « unrealizes », he does so approaching reality (which is also mystery), and yet his irony is in fact so « triumphant » that it no doubt prevented him from insisting on the mockery present in his painting — particularly during the brief « cow » period when he caricatured the Fauvist movement by caricaturing his own themes. Mystification works — when it does — if it is not evident.

So it goes with «mystery», and that is probably why mystery and mystification are so integrally linked in Magritte's work. A glass and an umbrella, which are not depicted as in a still life, but in contrast, painted to appear as religious objects; that is what must come through as a mystification! Yes, but Magritte is a « major » painter, and as soon as one begins to discern, in this glass and this umbrella, the very functioning of contradiction, one is already on the point of reintroducing mystery... So it is that opposites are posed side by side, and they are opposed to us. Where are we going?! This is the perpetual question-exclamation which no progress can answer and counter, where there is always something getting away and hiding.

The hidden is the subject of many of Magritte's paintings. His system of representation is simple: an object, a plant, a fruit, a bird, etc., hide the painting's center of interest. For example, a beautiful green apple dissimulates a person's visage and that is entitled *The Great War* (1964), a flower bouquet dissimulates the visage of a woman in 1900 dress, and that too is entitled *The Great War* (1964) (see p. 88). Patrick Waldberg cites a letter adressed to him in which Magritte explains what he showed there: « These paintings owe their interest to the existence — of which we are suddenly rendered conscious — of

LE BON VIVANT

The « Bon Vivant », undated. Drawing 6⁵/₁₆" x 5⁷/₈".
Collection: Isy Brachot Gallery, Brussels

the apparent visible and the hidden visible — which, in nature, are never separated. Something visible always hides something else, equally visible. But these paintings testify immediately — and unexpectedly — to this state of things. Something goes on in the world, between that which is visible and that which the visible hides, which is visible: a sort of combat that the title « *The Great War* » appropriately names. (Waldberg, p. 248).

One thing perpetually hides another, creating a dissimulation that can become mysterious. This dissimulation is a necessity of nature, and not some inventive creator's side effect. And the instant we have everything « in view », precisely at that instant « everything » robs us of the totality. The images of this « Great War » are of a literality that must be taken for and read as such; they are not symbols. But then, Magritte had a horror of symbols; he made it as clear as possible: « What I paint has nothing symbolic (there is nothing to interpret). I am not interested in symbols but in the thing symbolized... » And, « There is nothing "implied" in my painting, notwithstanding the error through which it is endowed with a symbolic meaning. How can one get a kick out of interpreting symbols? » (letter to Achille Chavée, Sept. 13, 1960).

The dissimulation effect creates the invisible, and consequently, the illusion. Thus one can understand the entire series *The Human Condition* (1933-5) and its numerous branch-offs such as *The Beautiful Captive* (1935), *The Call of the Peaks* (1943), *Euclid's Walks* (1955), *The Cascade* (1961), instead of viewing them as merely pictorial illusions by means of posing a painting in the painting — or as the broken windowpane retaining something like a vestige of fragments of the landscape; *Key of the Fields* (1933), *Arnheim's Castle* (1949). It also happens, in some paintings, that Magritte reverses the natural «givens» of illusion, by setting the stage for that which the very stage setting was to dissimulate; for example, in *The Banquet* (1958), where the setting sun is to be seen, before those trees that « ought » to have blocked off our view of it.

Magritte said that one could not provide a valid explanation of something until one had explained that explanation. Unable to do so, having tried to penetrate the functioning of these images, one can investigate their formation. The sketches for *A Bit of Bandit's Soul* (1960), as well as the outlines of glasses to be found in the letter to Suzi Gablik, demonstrate Magritte's work processes — Magritte thought visibly, that is to say, his image was formed by the association of objects to that initial object, setting out from which he had begun to pose questions. As Magritte explained in the following lines already cited: « An object, any subject taken as a question, was a matter of finding another object as answer, secretly bound to the first by links sufficiently complex as to give verification of the answer. If the answer became evident, the meeting of the two objects was striking ». (cf. *The Map-According to Nature,* 1952).

This « meeting of two objects » is the operation forming the mental object, that is to say, the image as it is finally represented in the painting. The formation of this image is analogous to the theory set forth by Reverdy in his celebrated article in *North-South.* «The image is pure creation of the mind. / It can spring, not from a comparison, but with the bringing together of two more or less separated realities. / The more the relation of these

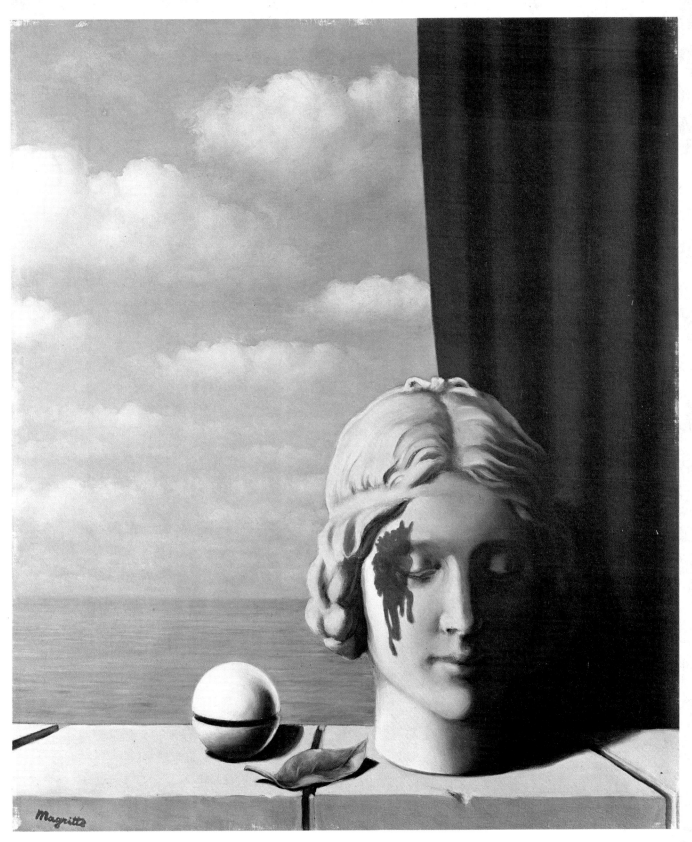

MEMORY, 1948
Oil on canvas, 28^1/$_2$" x 21^1/$_4$". Collection of the Belgian State

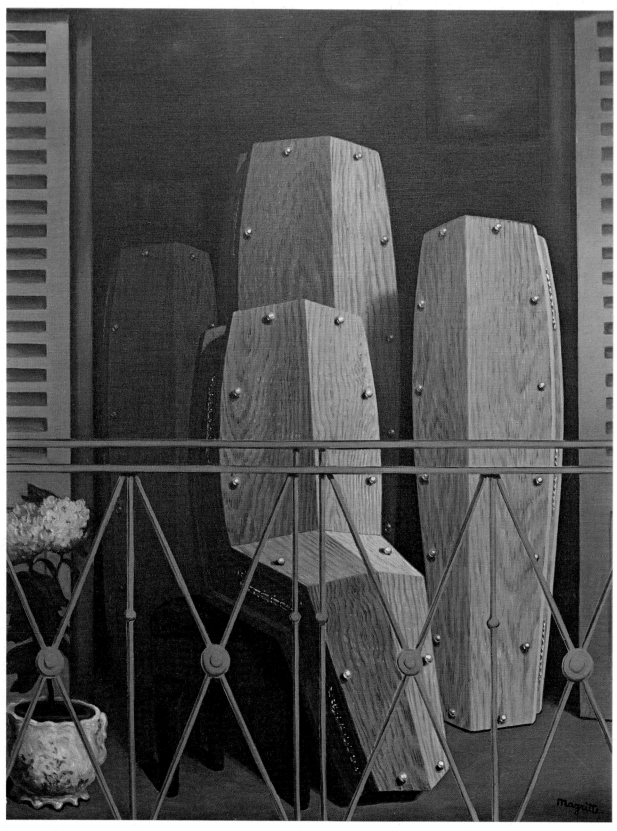

THE BALCONY, 1950
Oil on canvas, 31⁵/₈ x 23¹/₂". Collection: Museum voor Schone Kunsten, Gent

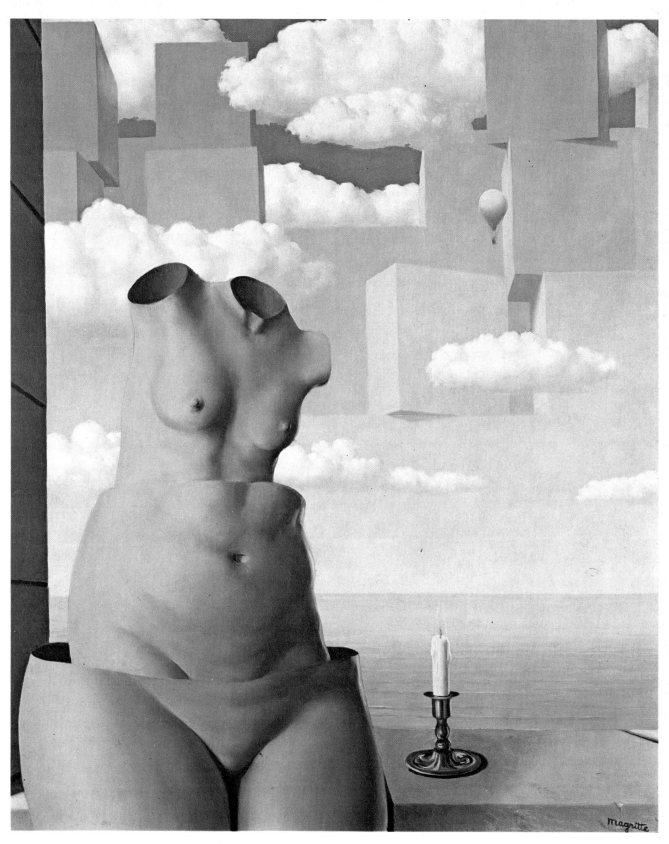

DELUSION OF GRANDEUR, 1948
Oil on canvas, 39" x 32". Collection: Hirshhorn Museum and Sculpture Garden,
Smithsonian Institution, Washington, D.C. ©

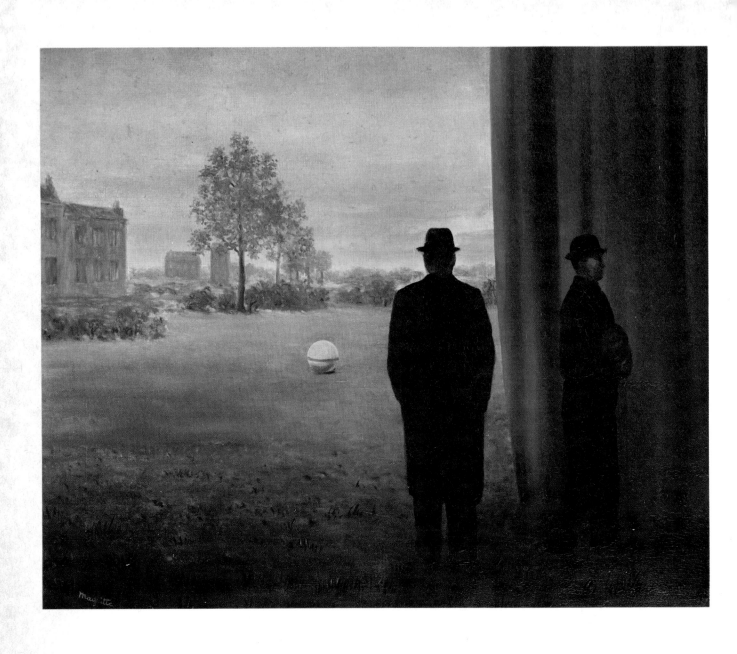

GOING TOWARDS PLEASURE, 1950
Oil on canvas, 19¹/₄" x 23".
Collection: Harry Torczyner, New York ©

PANDORA'S BOX, 1951
Oil on canvas, 17⁷/₈" x 21⁵/₈".
Collection: Yale University Art Gallery. Gift of Mr. and Mrs. John Cook ©

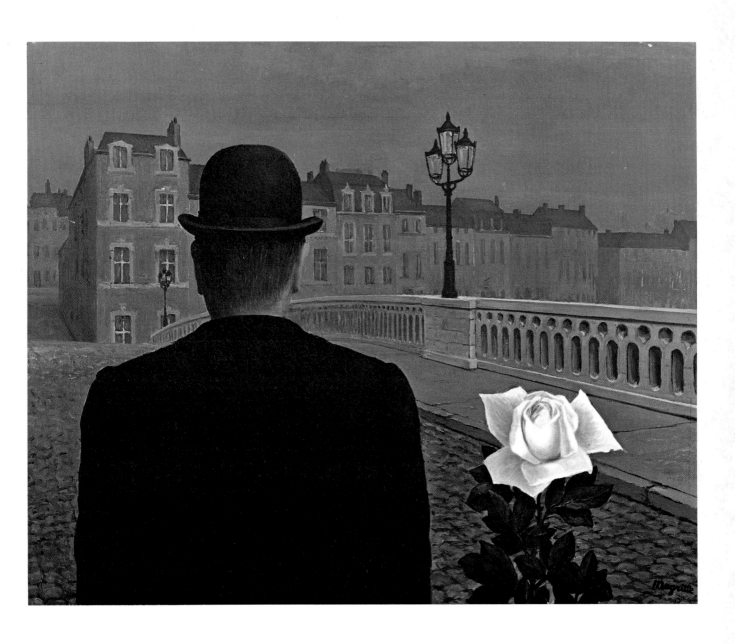

MEMORY OF A VOYAGE, 1952
Oil on canvas, 31⁷/₈" x 39".
Collection: Mrs. Jean Krebs, Brussels

◁

THE EXPLANATION, 1952
Oil on canvas, 14" x 18¹/₄".
Collection: Mr. and Mrs. Harry W. Glasgall, New York ©

59

THE EMPIRE OF LIGHT, II, 1950
Oil on canvas, 31" x 39".
The Museum of Modern Art, New York. Gift of Dominique and Jean de Menil ©

60

two realities is distant and precise, the stonger will be the image — it shall have that much more emotional power and poetic reality. / Two realities without relation cannot usefully be brought together. There would be no creation of image. / ...Analogy is a means of creation, it is a *resemblance of relations;* it is upon that, the nature of these relations, that the strength or weakness of the created image hinges. / ...One does not create image by comparing (always weakly) two disproportionate realities. / One creates, on the contrary, a strong image, new for the mind, by bringing together — without comparing — two distinct realities, of which *the mind alone* has grasped the relations ». (cf. *North-South, Self-Defense and Other Writings on Art and Poetry* (1917-1926), Flammarion, 1975).

Reverdy's vocabulary differs from Magritte's even though he, too, uses the word « resemblance ». Whatever the difference, Reverdy has given also an exact description of the work through which is elaborated, for instance, the meeting of glass and umbrella. Suzi Gablik, who maintained contact with Magritte for many years, writes: « The intention of Magritte was to create (...) fixed and autonomous images whose existence would no longer hinge on any "knowledge", and would be independent of our ideas regarding these objects (...) images which, to borrow Hegel's term, would become "concrete universals" ». (op. cit., p. 106).

Magritte himself is specific. « My paintings are images. The worthwhile description of an image is imposible without the orientation of thought toward its liberty ». « Liberty » which Magritte proceeds to define, « Liberty is the possibility to be, and not the obligation to be ». (cf. «Variations of Sadness », in *The Map According to Nature,* n. 9, August 1955.)

Magritte's images are composed of objects and elements in their « banality ». There is the tree with its trunk, its leaves, its roots, and the products of its wood; the chair, the table, the door, the wardrobe, the boards, the pipe, the easel, the coffin; there are the various components of the landscape: the sky, the clouds, the sea, the mountain, the plain, the shore; the house with its walls, the windows, the room, the fireplace... There are the curtains — a world in themselves — which Magritte will never abandon... The apple and the rose are often present; the knife, the fork, the bottle, the plate. Countless are the shelves, the sills, the props, whether they are of wall, of window, or of railing, as are the rattles (sphere marked with an equatorial slit), and the « bilboquets » (tumblers), derived from the balustrade, the chair foot, and the chess piece, which Magritte humanized in *Cicerone* (1945), and which — the one really bizarre object of Magritte's universe — recalls Chirico's mannequins. Equally numerous are the musical instruments (violin, bombardon), the silhouettes of cutup paper, candles (flexible ones, giant ones, and even, in *The Ignorant Elf,* 1957, a candle diffusing black light), the heads and busts in plaster, and still more numerous are the men in bowler hats, with the air of stationary objects. These men — an endless duplication of Magritte's double — are perennially garbed in black, while the figures of women, in general, are nude. The man's body is usually invisible; the woman's is beautifully visible in its full and harmonious nudity (*The Inundation,* 1931; *Black Magic,* 1935 (see p. 28); *Representation,* (1937); and yet, dissimulated or sensual, these bodies have no organic existence: they are forms. This was not the case prior to 1930, when several paintings such as *Blood*

of the World (1926), *Landscape* (1926), *Intermission* (1927) (see p. 19), *Discovery* (1928), and *The Forest* (1928), with their clumps of arteries and nerves and their bodily deformations, suggest a physical violence that will be absent from the post-1930 paintings, with the possible exceptions of *Rape,* in the boot-feet of *Red Model* (1935) (see p. 27), the eye in the ham slice of *Portrait* (1935) (see p. 26), or the breasted shirt of *Philosophy in the Boudoir* (1947).

It is too easy to contend that these objects are simply the painter's words; in fact, this inventory is less telling than their arrangement — than the sheer practice of their reading. A man in a bowler hat, a curtain traversing a cloudy sky trigger our recognition: it's a Magritte! Yet what we so recognize has far more to do with syntax and rhetoric than with vocabulary: things are registered, one may say, by articulation rather than their frequency. So it is that Magritte's rhetoric is comprised of a certain number of methods which René Passeron (op. cit., pp. 74-75) has brought down to five: physical contradic-

« *Lac Amour* », 1956 *Ball point pen* 10³/₈" x 7".
Private Collection, Southold New York

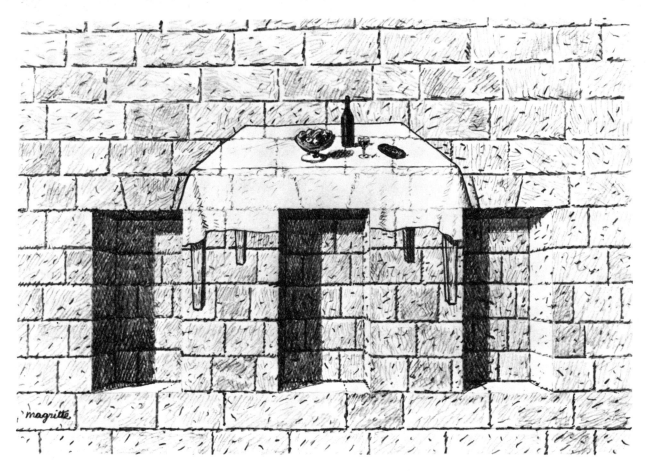

Drawing for the Lovable Truth, 1966 Pencil on paper
Private Collection, New York ©

tion (heavy / light; animal / mineral; day / night, etc.); logical displacement (egg for bird, leaf for tree, etc.); the odd superimposition (apple on the face, glass and bread on a man's back); reification (chair becoming wood, stone, etc.); absolute enigma (keyless enigma introducing nothing but the senseless). Magritte himself has enumerated his methods: « ...placing objects where we never meet them, creating new objects, transforming known objects, changing the matter of objects, using words associated with the images... » (« The Line of Life » in *Collective Invention*, n. 2, 1940).

These methods, in any event, are but ways of drawing an image. They do not explain its springing forth. Magritte, on this subject, spoke only of « inspiration » — another of his key words —; he said: « Inspiration is the event in which resemblance springs forth. Thought resembles, if at all, when inspired ». (op. cit. *L'Art Belge*). Inspiration, which makes resemblance spring forth, is thus the origin of thought. But then, what is Magritte's thought, if not the process of production of a visible that describes it, while identifying with it? The image is the act of thought. Magritte, in the same text,

is specific: « *Inspiration gives the painter what has to be painted:* resemblance is a thought liable to become visible by means of painting; for instance, the thought whose terms are a thought and the inscription "This Is Not a Pipe", or else the thought constituted by a nocturnal landscape under a sunny sky. "Theoretically", such thoughts evoke mystery, whereas "in fact" mystery is evoked by a pipe posed on an ashtray or by a nocturnal landscape under a sunny sky. It is to be noted that any image whatsoever, which contradicts "common sense", does not "theoretically", evoke mystery, if it is nothing other than a possibility of contradiction. Resemblance does not bother allying itself with or challenging "common sense". Spontaneously it reunites the shapes of the apparent world in an order offered by inspiration ».

Reading these lines, one may wonder if inspiration — Magritte never tells us what it is — which for him is surely not the magic wand that one automatically still tends to associate with this word — if inspiration, which labors as the letter to Suzi Gablik demonstrates, is not linked to our becoming aware of contradiction? This has nothing to do — Magritte underlines — with contradiction that simply seeks to counter "common sense", but with something more essential. Studying the entire text, one sees that contradiction must offer to inspiration what « inspiration offers to the painter », and thus that it finds resemblance. There is a sequence: contradiction, inspiration, resemblance, which accelerates the mental dynamic. Contradiction is the seizing of two opposing realities having a relation simultaneously contradictory and necessary. This is the case, for example, of the glass and the umbrella, or of day and night in *Good Adventure* (1939) and the celebrated series of *Empire of Light* (see p. 60). Contradiction is the velocity of our logical displacement from One to the Other in the seizing of their identity and of their irremediable difference: they are contraries and they *resemble.* Thought is that seizing which the image expresses by seizing it. Magritte goes further than Reverdy, for he sees and puts to work the contradiction that Reverdy utilizes without seeing. The Surrealists followed Reverdy, and their image is of the same blindness. (One will no doubt take me to task for not having pronounced the word «Surrealist » while speaking of Magritte's work. The trouble is that I clearly see what one subtracts from Surrealism by subtracting Magritte from it, but not at all what one subtracts from Magritte in subtracting, from him, Surrealism. Magritte and his friends were, of course, « Surrealists », but it has to do with another kind of Surrealism, so that it would be more than vexing to confound the two, with the same term).

In «The Theme of Contradiction in Magritte», an important article published in *L'Oeil* (n. 206-7), Vincent Bounoure clearly proves that behind all Magritte's methods there was « a single and same intellectual operation » at work: contradiction; he does not merely analyze it, in the images, but associates contradiction with the very labor of the painter, who depicts the real, but only at the price of a fiction. By means of the painting in the painting (series *The Human Condition*) or of the inscription «This Is Not a Pipe», Magritte manages to paint a negation. « And, Vincent Bounoure writes: As painting in "trompe l'oeil" was a constant putting on trial of painting, so the painting in the painting (like the episodic novel) seems to open a door onto reality through a double negation. Fiction in fiction,

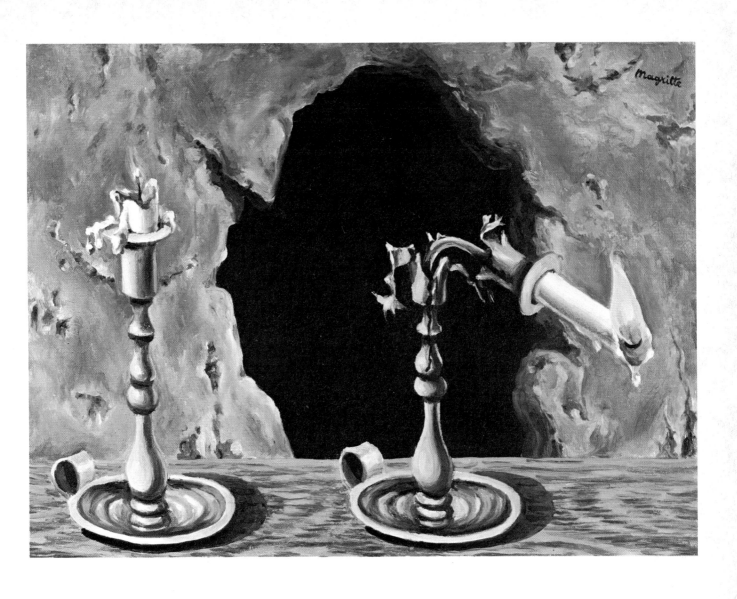

MELUSINE, 1952
Oil on canvas, 11³/₄" x 15¹³/₁₆"
Collection: Isy Brachot Gallery, Brussels

65

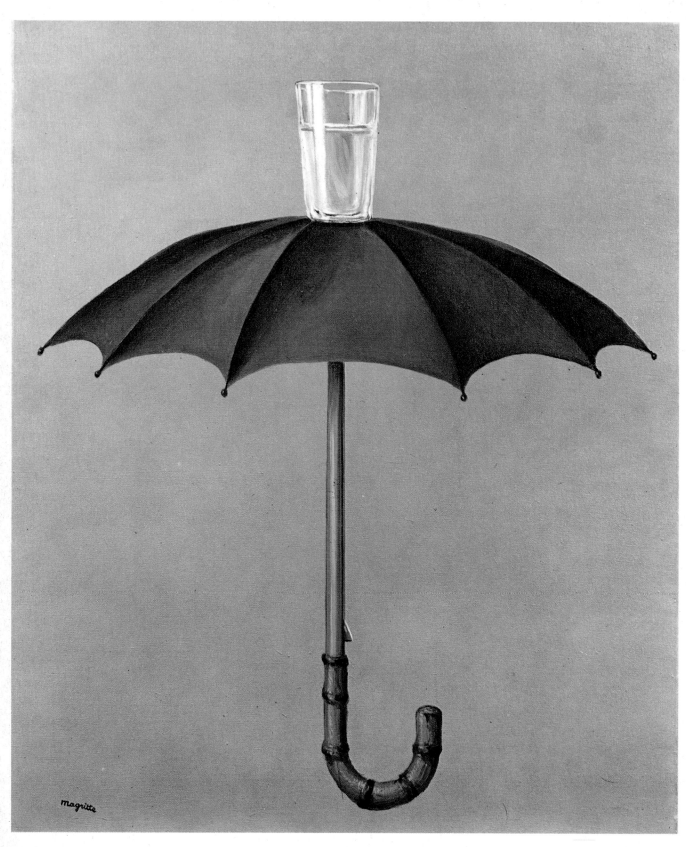

HEGEL'S VACATION, 1958
Oil on canvas, 23$^1/_2$" x 19$^7/_8$". Collection: Isy Brachot, Brussels

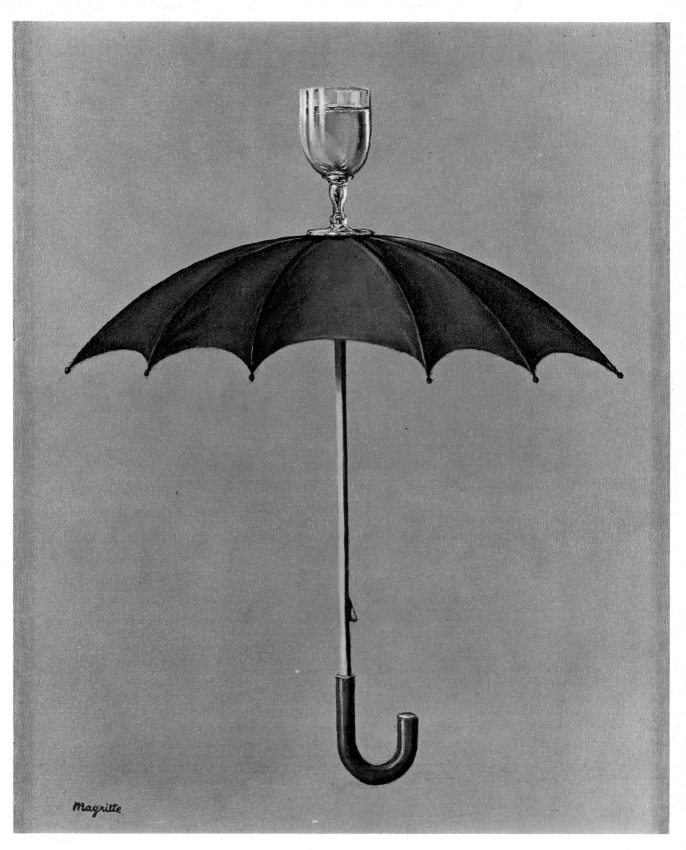

HEGEL'S VACATION, 1959
Oil on canvas, 18^{1}/$_{16}$" x 15". Private Collection

MEMORY OF A VOYAGE, 1955
Oil on canvas, 63⁷/₈" x 51¹/₄". Collection: Museum of Modern Art, New York ©

The Mason's Wife, undated. Drawing 7¹/₄″ x 10¹/₄″.
Collection: Mrs. Georgette Magritte, Brussels

"second-rank" fiction presented here as identical, not to reality but to "first-rank" fiction, the result being, thanks to a fatal extrapolation, that there is no fiction... ».

This reading is sound enough, but I prefer to return to the concept of the mental object that my pages have tried to lay down. Is the mental object fictitious? Proceeding from an ambiguity, it is and it is not. If the mental object is not fiction, its evocation, its image becomes *it*. Yet they become *it* as a decoy, which is a real object, but not the one it is taken for. The image is a decoy that, as soon as it *inspires* the spectator, once more becomes what it was — that is to say, the mental object. There is a departure-return, with a double metamorphosis. Here are a book, leaves, images, imprinted letters, they really exist, yet all that is but a fiction! Are thought's products less real than thought? When Magritte writes: « Thought resembles by becoming what the world endows it with and by restoring what it is endowed with, to the mystery... » — a phrase that I cite for the third time — I suppose that one must take his « becoming » very seriously and read: Thought resembles when it becomes the real... Decidedly images signify nothing except for that little bit of time that they give us to think!

70

THE KNOWLEDGE, 1961
Gouache and collage, 10¹/₄" x 13".
Private Collection, New York ©

˅

MUSICAL MOMENT, 1961
Gouache and collage, 16⁵/₈" x 11⁷/₈".
Private Collection, New York ©

72 *Study for the Beautiful Truths, undated. Drawing 7⁵/₁₆'' x 6⁵/₁₆''.*
 Collection: Isy Brachot Gallery Brussels

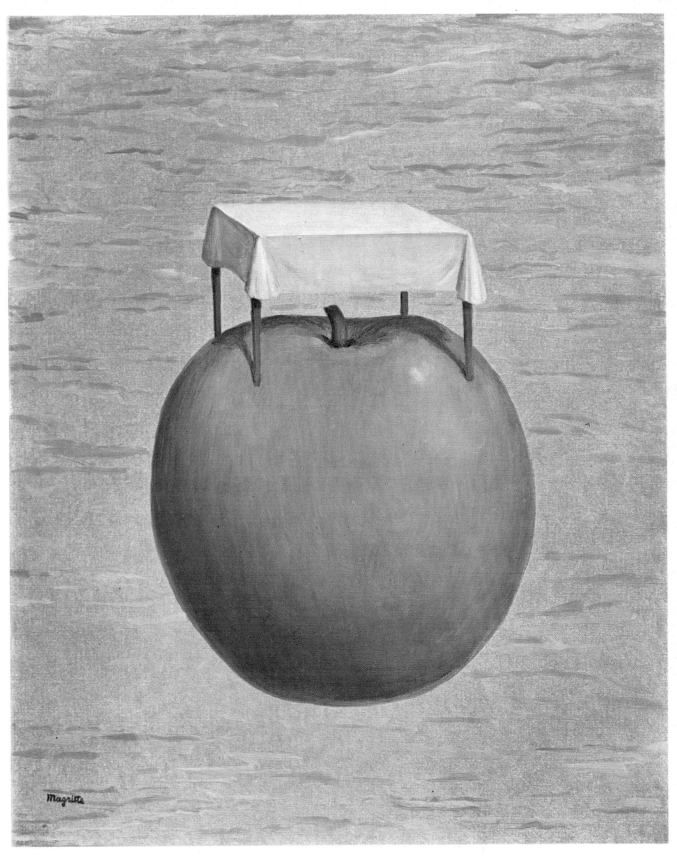

THE BEAUTIFUL TRUTHS, 1964
Oil on canvas, 19⁷/₈" x 15¹³/₁₆". Collection: Isy Brachot Gallery, Brussels

The Thought Which Sees, 1965 Graphite, 15³/₄" x 11⁵/₈".
Collection: The Museum of Modern Art, New York Gift of Mr. and Mrs. Charles B. Berenson ©

« Paysage de Baucis », 1966. *Original etching 9" x 6³/₄".*
Private Collection, Courtesy of Timothy Baum, New York ©

75

« LE SALON DE DIEU », 1958
Oil on canvas, 17¹/₄" x 23¹/₂".
Collection: L. Arnold Weissberger, New York ©

PLAGIARISM, 1960
Gouache, 12³/₈" x 10".
Private Collection, New York ©

76

Yes, but how is it that this time is so minutely counted?

« The perfect painting, responds Magritte, produces an intense effect during but a very short time, and sentiments resembling the first sentiment felt are to a greater or lesser extent soiled by habit... What with this law, the spectator must be disposed to experience a moment of unrivaled awareness, and admit his inability to prolong it» (*Manifestos and Other Writings,* pp. 106-7).

I view « my » umbrella / glass of *Hegel's Vacation.* And this time, which must be more than the hundredth, I try to discern the « wear » in my view. Why did Magritte not write, on an empty background: « This is neither a glass nor an umbrella? » Vain question, and yet not so vain, for it produces another: Why have I not spoken of the inscriptions, of the words in Magritte's paintings? Maybe I wished to avoid the inevitable this-is-not-a-pipe... André Blavier has made a survey of everything that has been written on the subject, in a short book, which, with its bibliography with commentaries (« This Is Not a Study »!) is a masterpiece of ironical decantation (*This Is Not a Pipe, Furtive Contribution to the Study of a Painting of René Magritte,* 1973), and Jacques Sojcher has demolished all the criticisms so as to renew our pleasure in the smoke (*The Pipe, its Poet, its Philosopher,* 1975).

Mathematical Logic, undated. Drawing $3^1/_8''$ x $5^1/_8''$.
Collection: Isy Brachot Gallery Brussels

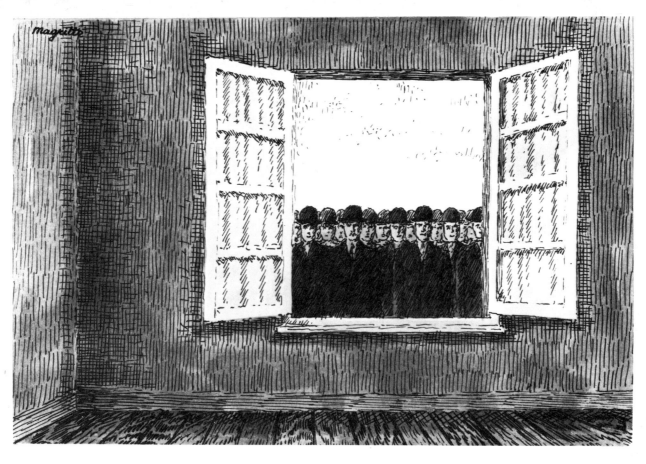

*Drawing for the «Month of Grape Gathering» 1959. Ink wash on paper, 7"x10¹/₂".
Private Collection, New York ©*

Virtually everybody has attacked « *This Is Not a Pipe* » (1973) by Michel Foucault, but this study proposes an expression: The « word-bearers » (les « porte mots ») which describes with exactitude and felicity those indistinct masses and those name-crossed cabinets among Magritte's first sets of paintings: *The Use of the Word, I* (1928), *Person Walking Toward the Horizon* (1928 or 1929), *The Empty Mask* (1928), *Blue Body* (1928). These word-bearers and the famous pipe are capable of withstanding all past and future commentaries to the extent that one does not forget, as Magritte said, that one must not confound the inedible image of bread and butter with bread and butter. So much said, Magritte never endeavored to depict things seeming uncannily « real »... It was not, for him, a matter of painting so «realistically» that the birds come to peck at his apples, but of making them *resemblant*. I have already made this statement: « Writing is an invisible description of thought and painting is its visible description ». What a temptation for someone who has so concluded to add the invisible to visible by painting words! And imediately the image pipes up the word « pipe », which can give as well as take, for after all it speaks of the invisible pipe, which is not to be confused with the first puff-a-pipe proffered... And here, so much the worse, I cite Jacques

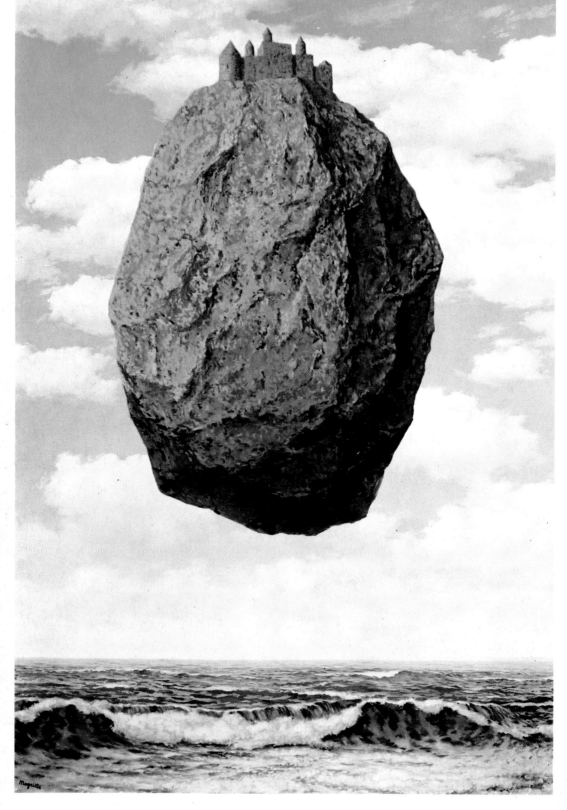

THE CASTLE
OF THE
PYRENÉES, 1959
Oil on canvas,
78³/₈" x 55".
Collection:
Harry Torczyner,
New York ©

Lacan: « to try to dupe a man, what you give him is the painting of a veil, that is to say, a painting of something beyond which he asked to see ». (*Seminar IX,* p. 103).

 The astonishing thing is that Magritte, considering the importance he accorded them, never painted the titles onto the paintings. The title — he repeatedly affirmed — is integrally part of the painting, and thus of its functioning. It is true that the title always accompanies the reproduction and that Magritte, who was not a collector and settled for reproductions, painted so as to be reproduced... The titles are neither symbolic nor explanatory. « The title of a painting, writes Paul Nougé, does not wed the painting as would a more or less subtle and exact commentary. But, thanks to the painting, the title is born of an illumination analogous to what it names » (op. cit., p. 238). The titles were often chosen collectively, in the course of weekly gatherings of which Magritte was the center. The choice of the title intervened only when the painting was completed: it was, in sum, its

Drawing for the Works of Alexander, undated. Pencil on paper, 11¹/₁₆″ x 14³/₁₆″.
Private Collection, New York ©

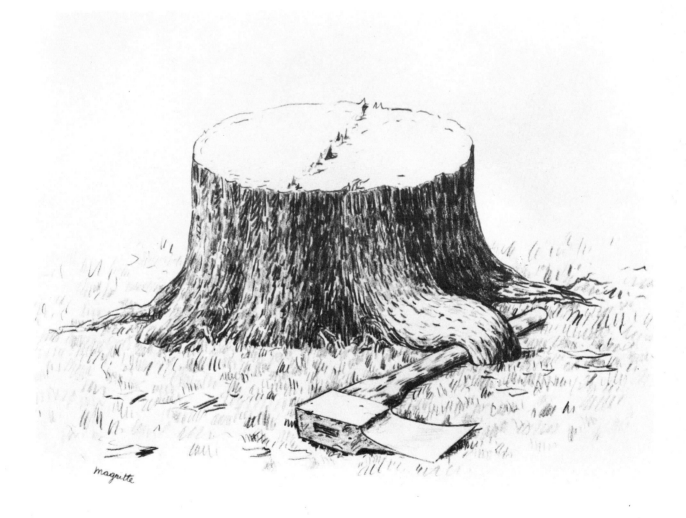

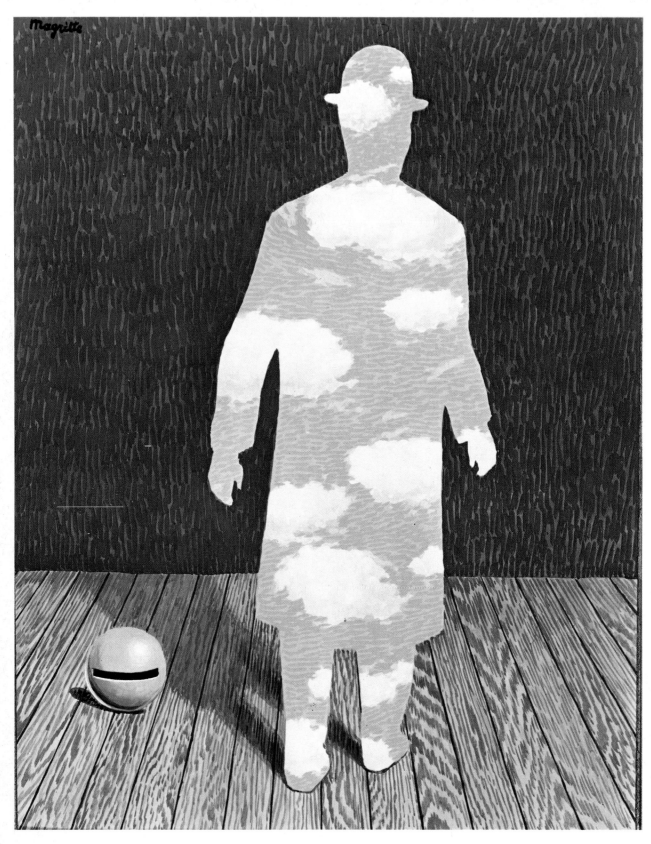

PRIVATE DIARY, 1964
Gouache, 13⁹/₁₀" x 10⁵/₈". Private Collection. New York ©

82

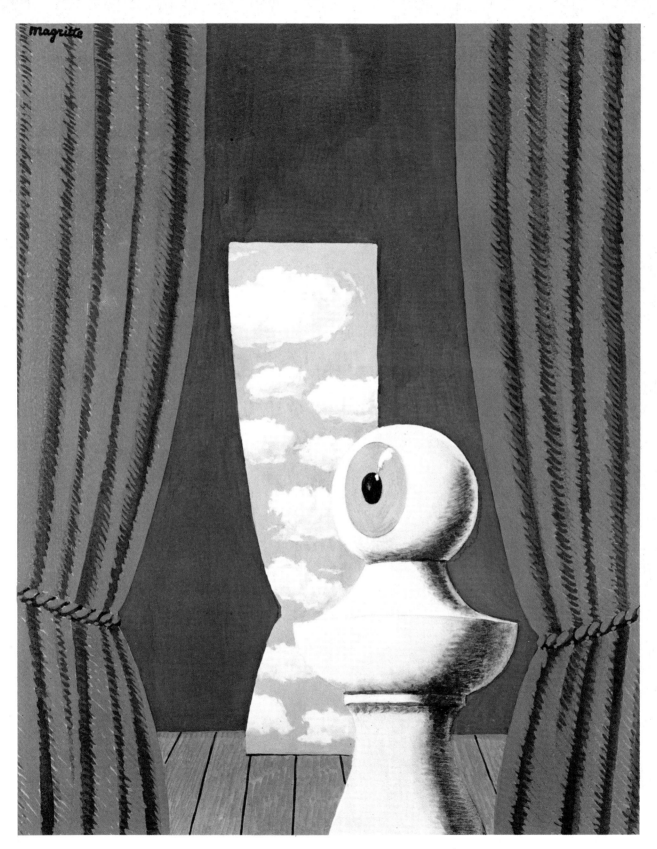

HOMAGE TO SHAKESPEARE, undated
Gouache, 13³/₄" x 10¹/₄". Collection: Evelyn Musher, New York ©

83

Study for the Tomb of the Wrestlers, undated. Pencil on paper.
Private Collection, New York ©

initial reading. And no doubt it is notable that here, once more, the « visible description » is supplemented by that « invisible description », which, already, espouses the movement of a mystery... a movement that ensures the titles not be painted, so that they are not confused with the words of the painting. And this is not a double game of illusion, at least not solely, but rather the fixing of the power of *inspiration* of the mental object through the other avatar of thought: writing.

So much said, it is evident that Magritte was always aware — as was Wittgenstein, with whom, not without reason, it is now in good taste to compare him — of the gap separating an object from its image or its name. But rather than clamor about the gap, Magritte puts the gap in his painting, and makes use of its « gaping ». The image and the title are the two precipices of this gap: it is up to us to leap into our bewilderment, or else, to cling to realism. « The titles, writes Magritte, are chosen in such a manner as to prevent the

84

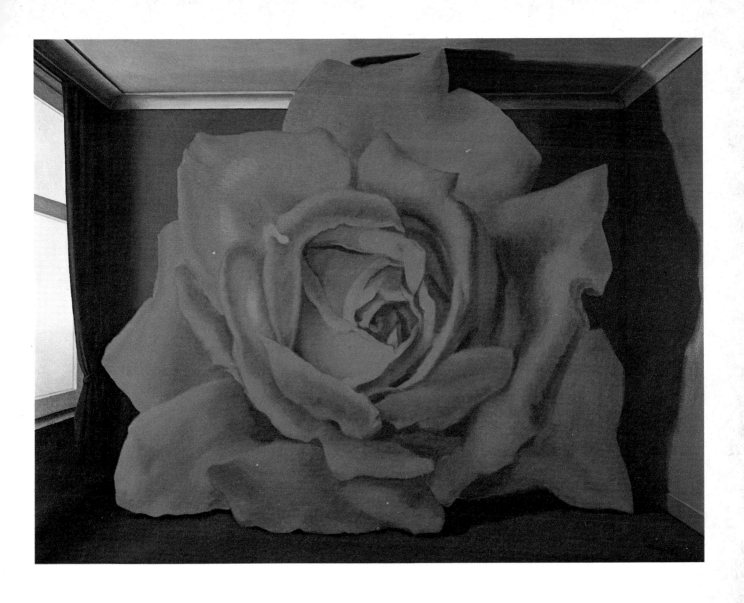

THE TOMB OF THE WRESTLERS, 1960
Oil on canvas, 35" x 46".
Collection: Harry Torczyner, New York ©

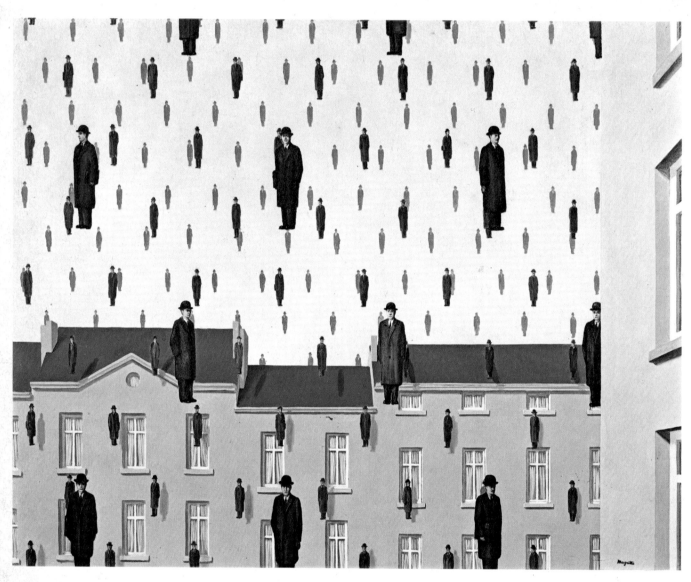

GOLÇONDA, 1953
Oil on canvas, 31^7/$_8$" x 39^3/$_8$".
Private Collection, U.S.A. ©

▷
THE WELL OF TRUTH, 1963
Oil on canvas, 32" x 23^1/$_2$".
Collection: Davlyn Galleries, New York ©

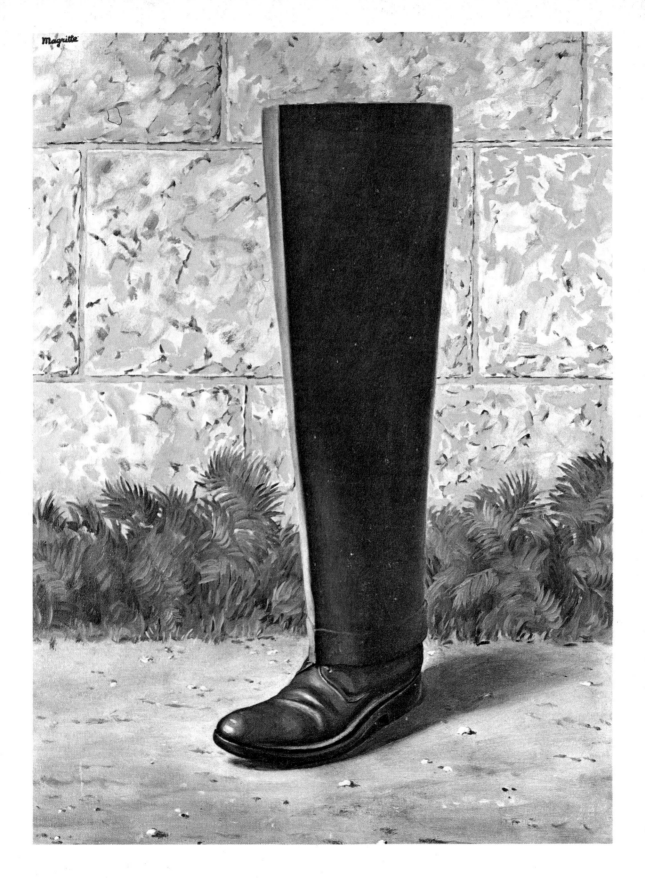

87

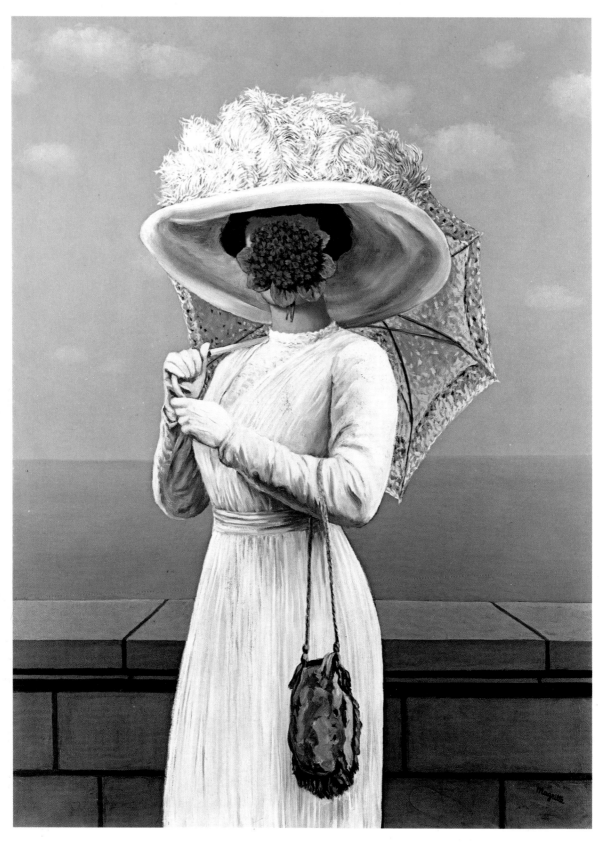

THE GREAT WAR, 1964
Oil on canvas, 31⁵/₈" x 23⁵/₈". Private Collection, Brussels

situating of my paintings in a familiar region, such as routine thought would not fail to do to avoid trouble ». The phrase is incisive, and it is interesting to note the use of the concept « routine thought », which is the contrary of the thought of resemblance.

And once again those words: « Thought resembles by becoming what the world endows it with... » The verb *become,* aside from its task of identification, does it not imply, here, the total engagement of painting, on the side of figuration? For Magritte, no doubt, painting could not but be figurative. Why? For the very reason that painting must be of use for something other than painting! The young Magritte, like his contemporaries, first had to grapple with the problem of originality, which seemed resolvable only by dint of the invention of a technique with another interpretation, etc. Then, and this was the turning point of his life, Magritte came upon *The Song of Love* by Chirico, which showed him that what one paints is altogether more important than the manner in which it is painted. On the subject of Chirico, in 1939, in his London Conference Magritte said: « It is the complete rupture with the mental habits proper to artists who are prisoners of talent, of virtuosity, and of all the pretty aesthetic specialties ».

So then, how to paint? « must be limited to the act of spreading colors on a surface, so that their factual aspect is delineated, and allows an image of resemblance to appear » (op. cit. *L'Art Belge*). The labor is in the thought, in the effort to attain « resemblance » and not in the painting, but it presupposes that the painting be mastered. After having surveyed the new techniques explored by Impressionism, Cubism, and Futurism, and noted that these have brought about but a short-lived exaltation, Magritte situates things precisely, in writing: « These technical researches being terminated (as well as their substitutes such as "abstract art", "non-figurative art", "constructivism", "orphism", etc.) the technical problem is posed accurately to the painter, that is to say, in terms of the result that one prescribes for oneself, and, under the condition that one master it, the considerable importance of the technique is brought back to its just dimension: of *means* ». (« The Veritable Art of Painting », in *Manifestos and Other Writings,* pp. 109-110).

In fact, what is avant-gardism? A noisy way of cornering the market. What counts is not the « novelty » of a work but its necessity — which entails, by the way, a supplement of novelty. When one eliminates Magritte with a yes, but... (yes, but his technique is traditional and contributes nothing to the art of our times), one eliminates thought, for the benefit of art. Thought troubles, art can only decorate, and as something decorative, it must change, like fashion, while thought can only continue.

And work — what work produces images and texts? Is it not that which, between the fiction already created and reality always to be created, tries to stitch up the wound of the gap, but does so without illusions, for the task is endless and the world unseizable... Like Magritte! « Where you'd seize him, he isn't, where you'd keep him, he's gone. His painting is our stealth » (Jacques Sojcher, op. cit.).

Thought does not concern itself with being modern, it is so, of necessity. And if thought, like work that produces it, is founded on contradiction, which painter, before Magritte, has managed to paint contradiction?

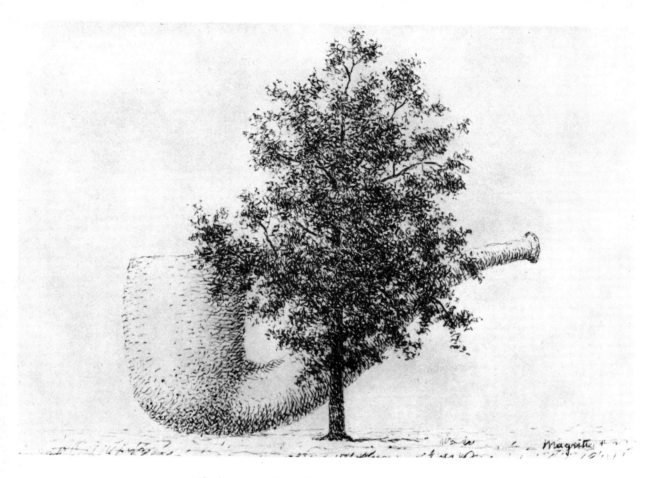

Shadows, undated. Drawing, 7¹/₈" x 10¹/₄".
Private Collection, New York ©

« The art of painting is an art of thinking, whose existence underscores the importance of the role played in life, by the eyes of the human body... The art of painting has, as a goal, to render perfect the functioning of the view, thanks to a pure visual perception of the exterior world, by the sole sense of sight. A painting conceived with this goal in mind is a means of replacing the spectacles of nature, which generally provoke nothing but a mechanical functioning of the eyes, because of the habit that veils these natural spectacles, always similar, or always previewed in advance... ». (« The Veritable Art of Painting », op., cit., pp. 102-103).

The world could be the open book of the thought of the world, but habit shuts our eyes so that we are not in the world. The thinker would awaken the look, but for that, he has to rewrite the book of the world... Here, once again, the phrase: « Thought resembles by becoming what the world endows it with and by restoring what it is endowed with, to the mystery without which there is no possibility of world, no possibility of thought... »

The thinker writes, but what can he write, if not resemblance? « I write, says

90

Edmond Jabès, with resembling words resembling the book ». Yet resemblance spurs the return of that which it resembles: it reopens the book of the world in which, it is submerged. Images are unbearable. Visible thought changes — into itself — the mystery of the world, and having become it, is lost. But the mystery of the world is unbearable. And the unthought, once again, seeks the life of an image, with which it will yield to its contrary, then mysteriously escape it. Everything existing finds its form in its very possibility, which it constitutes. But if the existing is to appear and materialize, it must meet its resemblance, in visible thought.

BERNARD NOËL

ARCH OF TRIUMPH, 1960
Oil on canvas, 51^1/$_5$" x 65". Private Collection, New York ©

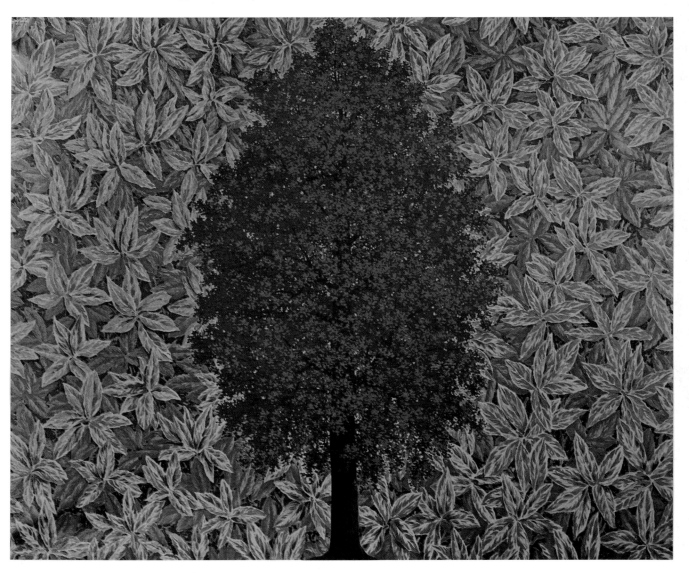

We wish to thank the owners of Magritte paintings reproduced
in this work

Museums: Musée des Beaux-Arts, Gent • Musée national d'Art moderne,
Paris • Tate Gallery, London • Art Institute of Chicago •
Hirshhorn Museum and Sculpture Garden, Smithsonian Insti-
tution, Washington D.C. • Museum of Modern Art, New York •
Yale University Art Gallery, New Haven.

Art Galleries: Galerie Isy Brachot, Brussels • Davlyn Galleries, New York

Private collections: Mr. and Mrs. Isy Brachot, Brussels • Mrs. Jean Krebs,
Brussels • Mrs. Georgette Magritte, Brussels • Mr. and Mrs.
Nesuhi Ertegun, New York • Mr. and Mrs. Harry W. Glasgall,
New York • Mrs. Evelyn Musher, New York • Mr. Harry
Torczyner, New York • Mr. L. Arnold Weissberger, New York.

Photography credits: Raf an den Abele, Gent • E. Dulière, Brussels • Luc
de Heusch, Brussels • J. Hyde, Paris • O. Nelson, New York •
Nathan Rabin, New York • J. Szasfai, New Haven.

BIOGRAPHY

1898. November 21, birth of René François Ghislain Magritte at Lessines, in the Hainaut (Belgium), where his father is a merchant. He has two younger brothers, Raymond and Paul, his favorite. The family moves to Gilly, then to Châtelet.

1912. Régina Magritte, René's mother, jumps into the Sambre River one night and is drowned. « The one sentiment that Magritte remembers — or imagines he remembers — pertaining to this event, is that of strong pride at the thought of being the pitiable center of a drama » (Scutenaire).

1913. The Magritte family at Charleroi. At the fair, René Magritte meets Georgette Berger, aged thirteen. They take to one another, but are separated. Magritte is excited by the exploits of Nick Carter and Nat Pinkerton, and the films of Fantomas.

1915. First paintings.

1916. Magritte enters the Académie des Beaux-Arts of Brussels. Professors: Gisbert Combaz and Constant Montald. Friendship with Victor Servranckx.

1919. Is associated with Pierre Bourgeois and Pierre-Louis Flouquet, future organizers of the *Journal des poètes,* through whom he shall discover Futurism.

1920. Once more meets, by chance, Georgette Berger, with whom he will live and whom he later marries. Is associated with ELT Mesens, Nougé, Goemans.

1921. Military service.

1922. Marries Georgette Berger. Works in the wall paper factory, Peters Lacroix. Friendship with Marcel Lecomte, who reveals Chirico to him: decisive shock. Edits a manifesto with Servranckx, *L'Art pur. Défense de l'esthétique,* never published.

1923-24. Abstract paintings, which illustrate the positions taken in the manifesto.

1925. *The Lost Jockey,* work considered the first « Magritte ». He paints frequently and contributes to numerous magazines: *Oesophage, Marie* « bimonthly newspaper for the Beautiful Young »...

1926. Is associated with Louis Scutenaire.

1927. First exhibition, Le Centaure Gallery, Brussels, which gives him a contract. Magritte devotes himself exclusively to painting. In August, departure for France; he takes up abode at Perreux-sur-Marne, near Paris. Participates in the Surrealist gatherings.

1928. Exhibits collages with the Surrealist painters at the Goemans Gallery. The catalogue includes Aragon's celebrated text, *Painting Challenges (La Peinture au défi).* Dispute with André Breton. Magritte returns to Brussels. He will stay there permanently, except for brief journeys.

1935. Is associated with Paul Colinet.

1936. First exhibition in New York, at the Julien Levy Gallery. Contributes to the Communist newspaper la *Voix du peuple,* under the pseudonym of Florent Berger, his father-in-law's name.

1937. Exhibition in London: the London Gallery.

1939. Is associated with Marcel Mariën.

1940. Stays at Carcassonne, close to Joé Bousquet, during the post-June exile, then returns to Brussels; beginning of « Impressionist » researches which shall lead to the work of the period known as « full sun » (« plein soleil »).

1943. Private exhibition of the new Magritte painting, July 11-18 in Brussels. First monograph, the *René Magritte* by Marcel Mariën.

1944. Public exhibition in Brussels, of the new Magritte painting. Marc Eems sharply attacks this « degenerate art » in the newspaper edited, in Flemish, for volunteers for work in Germany.

1945. He publishes in the Communist newspaper, *The Red Flag,* a « Homage to James Ensor », which causes a scandal.

1946. New dispute with André Breton and publication of the manifesto *Surrealism in Full Sun,* against Parisian Surrealism and its « love of art ».

1948. Period of caricatures known as the « période vache » and the exhibition of twenty canvases and gouaches at the Faubourg Gallery, in Paris. Cold welcome.

1953. *Le Domaine Enchanté,* large mural for the Casino of Knokke-le-Zoute. Exhibitions in London, New York, Rome, Paris.

1954. First large-scale Magritte retrospective at the Palais des Beaux-Arts, Brussels.

1956. Guggenheim Prize for Belgium.

1957. *The Ignorant Elf (La Fée Ignorante),* mural for the Palais des Beaux-Arts, Charleroi.

1965. Large retrospective at the Museum of Modern Art, New York.

1967. Retrospective at the Boymans Van Beuningen Museum, Rotterdam.
August 15, death of René Magritte, at Brussels.

BIBLIOGRAPHY

1. - BOOKS:

BLAVIER André, *Bibliographie générale de René Magritte* (until 1965), at the end of the book by Patrick Waldberg, pages 285 to 336.
Ceci n'est pas une pipe. Contribution furtive à l'étude d'un tableau de René Magritte, Verviers, Temps mêlés, 1973.

DEMARNE Pierre, *René Magritte,* Rhétorique n° 3, September 1961.

FOUCAULT Michel, *Ceci n'est pas une pipe,* Montpellier, Fata Morgana, 1973.

GABLIK Suzi, *Magritte,* London, Thames and Hudson, 1970

HAMMACHER A.M., *Magritte* New York, Abrams, 1974.

LARKIN David, Introduction by Eddie Wolfrom, *Magritte,* New York, Ballantine, 1976.

LEBEL Robert, *Magritte, peintures,* Paris, Fernand Hazan, 1969.

MARIËN Marcel, *René Magritte,* Brussels, les Auteurs associés, 1943.

MICHAUX Henri, *En rêvant à partir de peintures énigmatiques,* Montpellier, Fata Morgana, 1972.

NOUGÉ Paul, *Histoire de ne pas rire,* Brussels, Les Lèvres nues, 1956.

PASSERON René, *René Magritte,* Paris, Filipacchi, 1970.

ROBERT-JONES Philippe, *Magritte poète visible,* Brusselles, Laconti, 1972.

SCUTENAIRE Louis, *René Magritte,* Brussels, Librairie Sélection, 1947.
Magritte, Antwerp, De Sikkel, 1948.

SOBY James Thrall, *René Magritte,* New York, The Museum of Modern Art, 1965.

SOJCHER Jacques, *La Pipe, son peintre, son philosophe,* Brussels, Dissertation (typewritten), 1975.

VOVELLE José, *Le Surréalisme en Belgique,* Brussels André De Rache, 1972. (See p. 63-164. A significant study on René Magritte)

WALDBERG Patrick, *René Magritte,* Brussels, André De Rache, 1965. Contains the Bibliography by André Blavier.

2. - ARTICLES: A selection of the principal articles. Also note l'*Art Belge,* special issue on René Magritte, January 1968.

ALLOWAY Lawrence, Portrait of the artist, *Arts News and Review,* n° 21, November 1953.

BOUNOURE Vincent, Le Thème de la contradiction chez Magritte, *L'Œil,* n° 206-207, February-March 1972.

CALAS Nicolas, Pearls of Magritte, *Arts Magazine,* April 1972.

GABLIK Suzi, René Magritte: Mystery Painter, *Harper's Bazaar,* n° 3024, November 1963.
Meta-trompe-l'œil, *Art News,* n° 1, March 1965.
A Conversation with René Magritte, *Studio International,* n° 387, March 1967.

JOUFFROY Alain, Magritte, *Jardin des Arts,* n° 66, April 1960.

LEBEL Robert, Avant et après Magritte, *L'Œil,* March 1968.

LECOMTE Marcel, Quelques tableaux de Magritte et les textes qu'ils ont suscités, *Bulletin des musées royaux des Beaux-Arts de Belgique,* n° 1-2, 1964.

MESENS E.L.T., The World of René Magritte, *The Saturday Book,* n° 19, 1959.

SCUTENAIRE Louis, Gloser à propos de l'exposition parisienne des œuvres de René Magritte est prématuré. Allons-y donc!, *Au Miroir d'Elisabeth,* May 1948.

En parlant un peu de Magritte, *Cahiers d'Art,* n° XXX, 1955.

L'Œuvre peint de René Magritte, *Savoir et Beauté,* n° 2/3, 1961.

TORCZYNER Harry, The Magic of Magritte, *The Art Gallery,* n° 4, January 1964.

VAN HECKE Pierre-Gustave, René Magritte peintre de la pensée abstraite, *Sélection,* March 1927.

VOVELLE José, Magritte et le cinéma, *Cahiers Dada Surréalisme,* n° 4, 1970.

Un surréaliste belge à Paris: Magritte 1927-1930, *Revue de l'Art,* n° 12, 1971.

3. - CATALOGS (main):

1927 : Galerie Le Centaure, Brussels. « La Peinture de René Magritte » by P.-G. Van Ecke and « Les Circonstances de la peinture » by Paul Nougé.

1933 : Palais des Beaux-Arts, Brussels. « L'Avenir des statues » by Paul Nougé.

1948 : Galerie du Faubourg, Paris. « Les Pieds dans le plat » by Louis Scutenaire.

1954 : Palais des Beaux-Arts, Brussels. « La Pensée et les Images» and «Esquisse autobiographique» by René Magritte. « L'eau qui a coulé sous les ponts » testimonies.

1955 : Galerie Cahiers d'Art, Paris. « Un Art poétique » by René Magritte.

1960 : Musée des Beaux-Arts, Liège. « René Magritte ou la Connaissance du monde » by André Bosmans. Bibliography by André Blavier and André Bosmans.

1961 : Obelisk Gallery, London. « L'Art de la ressemblance » by René Magritte and « Appreciations of Magritte » by Jean Arp, André Bosmans, Pierre Bourgeois, etc.

Albert Landry Galleries, New York. Introduction by Harry Torczyner.

1962 : Casino communal de Knokke-le-Zoute. L'Œuvre de René Magritte, Editions de la Connaissance, Brussels. Essais sur Magritte de P.-G. Van Ecke, Louis Scutenaire, Paul Nougé, E.L.T. Mesens, Pierre Demarne and Marcel Lecomte. « Esquisse autobiographique » by R.M. « Le Domaine enchanté » by Paul Colinet.

Walker Art Center, Minneapolis, USA. Introduction by Suzi Gablik.

1964 : Arkansas Art Center, Little Rock, USA « Envergure de René Magritte » by André Breton and « The Breath of René Magritte » by W.G. Ryan.

1965 : The Museum of Modern Art, New York. The book of James Thrall Soby is used as catalog.

1967 : Gallery Alexandre Jolas, Paris. « Les Images en soi ». « Divagations d'un amant maladroit » by Gui Rosey. Short text without title by Louis Scutenaire.

Museum Boymans van Beunningen, Rotterdam. Introduction by Jean Dypréau. Bibliography of Magritte's writings.

1969 : Tate Gallery, London. Introduction by David Sylvester. Catalog published by The Arts Council of Great Britain (136 pages).

1972 : Grand Palais, Paris. « Peintres de l'imaginaire »: Belgian Symbolists and Surrealists.

4. - EXHIBITIONS. At the time of his death, Magritte had shown his works in some three hundred exhibitions. The principal ones correspond to the catalogs mentioned above. One might list besides:

1936 : Julien Levy Gallery, New York.

1947 : Hugo Gallery, New York.

1953 : Galleria dell'Obelisco, Rome.

1954 : Sidney Janis Gallery, New York.

1962 : Alexander Jolas Gallery, New York.

1964 : Hanover Gallery, London.

1965 : Alexander Jolas Gallery, Genova, Paris, New York.

1971 : Museum of Modern Art, Tokyo and Museum of Modern Art, Kyoto.

5. - WRITINGS by René Magritte:

There are about fifty texts which have been cataloged by André Blavier in his Bibliography, published at the end of the book by Patrick Waldberg. Since then, the following have been published in one volume: René Magritte, *Manifestos and Other Writings,* Brussels, « Les Lèvres nues », with a Warning by Marcel Mariën. This work of 175 pages (the warning covering pp. 9-31) reproduces texts written between 1946 and 1950, in which he opposed his « Surrealism in Full Sunshine » to André Breton's version of Surrealism, and in which he presented, for the first time, his manifestos on « Amentalism » and « Extramentalism ».

ILLUSTRATIONS